IMAGES
of America

HYANNIS AND HYANNIS PORT

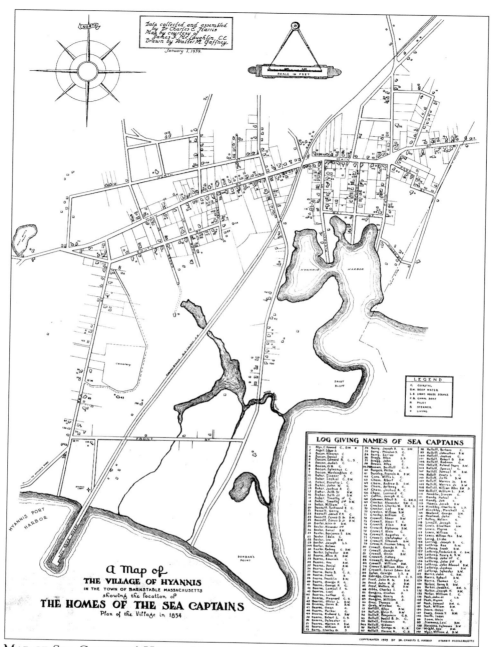

A MAP OF SEA CAPTAINS' HOMES. Hyannis in the 19th century was home to dozens of sea captains. Charles E. Harris, James F. McLaughlin, and Walter M. Gaffney made this map in 1939 from an 1854 plan of the village. Notice that South Street once ended at Pearl Street. When it was continued through to Pleasant Street, the new section was originally called Hallett Street. Eventually, the entire stretch was called South Street. Dunbar's Point, at the bottom of the map, was later given to the town by Centerville resident Herbert Kalmus, who was the coinventor of Technicolor. The area became a popular town beach known as Kalmus Park. (Courtesy of Town Clerk Linda Hutchenrider.)

IMAGES
of America

HYANNIS AND HYANNIS PORT

Jennifer Longley

ARCADIA

First printed in 2002.

Published by Arcadia Publishing,
an imprint of Tempus Publishing, Inc.
2A Cumberland Street
Charleston, SC 29401

Printed in Great Britain.

Library of Congress Catalog Card Number: 2002100843

For all general information contact Arcadia Publishing at:
Telephone 843-853-2070
Fax 843-853-0044
E-Mail sales@arcadiapublishing.com

For customer service and orders:
Toll-Free 1-888-313-2665

Visit us on the internet at http://www.arcadiapublishing.com

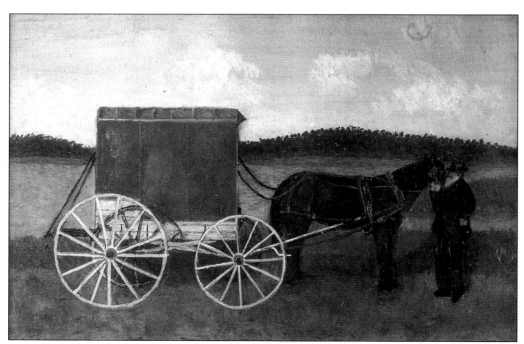

HIRAM HAMBLIN. Like many fishermen of his time, Hiram Hamblin sold his catch around Hyannis from the back of his wagon. Hamblin was the grandfather of Harry Bearse (owner of Bradford's Hardware) and the great-grandfather of author Alvah W. Bearse. He built his home on Ocean Street on land he purchased in 1845 from Asa Bearse. Bearse had bought the land from Rodney Baxter. Hamblin and his wife, Evelina, had four daughters. (Courtesy of Alvah W. Bearse.)

CONTENTS

Acknowledgments 6

Introduction 7

1. On the Waterfront 9

2. Business and Industry 27

3. Hyannis Society 39

4. Memorable Townspeople 75

5. The Railroad 89

6. The Kennedys in Hyannis Port 97

7. Historic Homes 111

8. Disasters 119

ACKNOWLEDGMENTS

This book would not have been possible without the enormous generosity of the *Barnstable Patriot* newspaper, particularly publishers Rob and Toni Sennott, editor David Still II, and associate editor Edward F. Maroney. Issues of the newspaper on microfilm were also an indispensable source of research. I would also like to recognize with deep appreciation Sancy Newman, who lent me many of the photographs of Hyannis Port, many of which appeared in the book *Old Hyannis Port*, by Larry G. Newman and Paul F. Herrick. Alvah W. Bearse, who wrote *Physic Point*, a book about his childhood in Hyannis in the early 20th century, was a valuable source of information. He shared his memories with me, gave me access to his notebooks and photographs, and was an inspiration to me. Britt Steen Zuniga, the author of *Centerville* and the director and curator of the Centerville Historical Museum, offered valuable advice and assistance.

I would also like to thank Gina Barboza of the Woods Hole, Martha's Vineyard and Nantucket Steamship Authority, Samuel T. Baxter, the Barnstable Historical Society, the Barnstable town archives, Ed and Sandy Bond, Hyannis fire chief Harold Brunelle, Gordon E. Caldwell, Roger Carchrie-Feltus, James Cedrone and James B. Hill of the John Fitzgerald Kennedy Library and Museum, the Centerville Historical Society, Rev. Ellen Chahey of the Federated Church, Philip H. Choate, former Hyannis fire chief Glenn Clough, Mary Crocker, William and Lois Crocker, David Doolittle, Paul Drouin, Linda Field of Colonial Candle of Cape Cod, Eugenia Fortes, Ted Gelinas, Susan Godoy, Jim Gould, Alan and Janice Granby, Byron Hall, Ann-Louise Harries and Carol Saunders of the Hyannis Public Library, Elsie Hudson, Town Clerk Linda Hutchenrider and her staff, the John F. Kennedy Hyannis Museum, Donald Megathlin, Susan Milk, Arnold Miller of the *Cape Cod Times*, Erin O'Neil Moore, Joanne Murphy, Elna Nelson, the Nantucket Historical Association, Van Northcross of Cape Cod Hospital, Wendy Northcross of the Cape Cod Chamber of Commerce, Rebecca Pierce of the John F. Kennedy Hyannis Museum, Lynne Poyant of the Hyannis Area Chamber of Commerce, Bill Putman of the Simmons Homestead Inn, Tony Raine of the Cape Cod Melody Tent, Adolphe Richards, Ellen Sullivan Rivers, Richard Robinson of Bradford's Hardware, David Rosenfield, Ruth Rusher, Ann S. Ryan, Richard Scudder of Hy-Line, Robert and Priscilla Sherman, Mary Sicchio of Cape Cod Community College, Sturgis Library, Sean Walsh, and Elizabeth Mumford Wilson.

I would also like to thank Thomas K. Lynch and Robert and Nancy Longley for all their help, advice, and encouragement.

INTRODUCTION

Hyannis is one of seven villages in the Cape Cod town of Barnstable. The others are Centerville, Osterville, Cotuit, Marstons Mills, Barnstable, and West Barnstable. Hyannis Port, a neighborhood within Hyannis, is so named because it was the port for Hyannis before the harbor was dredged, allowing larger ships to travel into it. The word *Hyannis* is probably a derivation of the name of the Native American sachem Yanno, who in 1664 sold to early settlers much of the land that now makes up Hyannis. Early documents refer to Yanno's Harbour and Yanno's lands. Hyannis's rich history is filled with sea captains, boatbuilders, enterprising immigrants, merchants, educators, and entrepreneurs.

Hyannis has been the hub of Cape Cod since the days of sail. That reputation was further strengthened when the railroad reached the village and the tracks were extended to the south shore along Nantucket Sound so that trains could meet ships coming in with passengers and cargoes of coal, lumber, fish, grain, and mail. The village's economy was once tied to the sea and later to tourism.

It was a proud and heady time for the village when summer resident John F. Kennedy was elected president in 1960. The president and his family loved Cape Cod, and many Kennedys considered Hyannis Port home. This book includes some memorable photographs of the family enjoying seemingly carefree summer days in Hyannis Port, a quiet enclave of weathered summer homes that has come to be synonymous with the Kennedy name.

This book does not attempt to fully chronicle Hyannis's long and fascinating history. Rather, it offers snapshots of village's history from the mid-19th century to the mid-20th century. Perusing these pages, you will meet Louis Arenovski, a Lithuanian immigrant who arrived on Cape Cod anonymous and with little money and rose to become one of Hyannis's most popular and influential businessmen. You will meet Clara Jane Hallett, an outspoken, witty, and independent writer who spent nearly her entire life in the Ocean Street house where she was born. You will read about Edward Petow, a native of Russia who pioneered the artificial-pearl industry in Hyannis; Capt. Rodney Baxter, who built the octagonal house on South Street; and John Bodfish, who became a lawyer after he went blind. You will see the first house built in Hyannis and beautiful scenes of the harbor as it looked c. 1900. You will learn some of the history of the State Normal School at Hyannis and of businesses like Baxter's Boathouse Club restaurant and Bradford's Hardware. You will read about the emergence of tourism and see dramatic photographs of some of the fires and other disasters that have struck Hyannis.

Although the village changed enormously during the 20th century, many readers familiar with Hyannis will recognize some of the seascapes, streetscapes, landmarks, and buildings depicted in this collection of images. Most of the photographs, however, were taken at a time foreign to most of us today. Clara Jane Hallett might have put it best when she wrote in the 1940s, when she was an elderly woman, "We had no telephones, no automobiles, busses or taxis, no mail delivery, no green vegetables in winter, no steam-heated houses, no movies, and

bathrooms and bath tubs were almost unknown. But somehow we lived and thrived and found happiness. We had camp meetings in summer, picnics, sailing parties, rides on the steam cars, dances and plays in the old Masonic Hall, lectures, old folks concert, singing schools, spelling bees, buggy rides, hay rides, sleigh rides. . . . We knew every one and they knew us. We had neighbors and friends always coming and going and we did not expect as much of life as people do today."

Hopefully, *Hyannis and Hyannis Port* will give you a glimpse of what life was like back then.

This book is dedicated to the people of Hyannis.

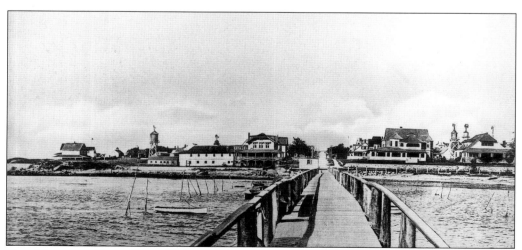

THE HYANNIS PORT PIER. This *c.* 1894 photograph of the Hyannis Port pier shows the Hyannis Port neighborhood from the water. (Courtesy of the Newman collection.)

One
ON THE WATERFRONT

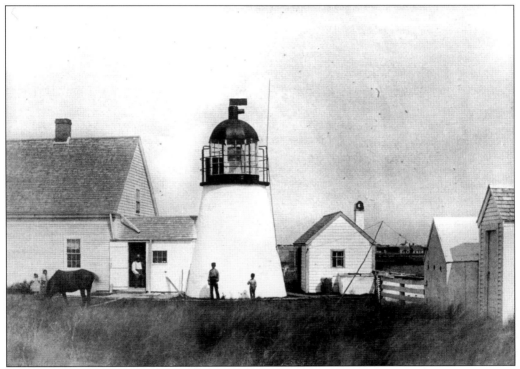

SOUTH HYANNIS LIGHT. Unlike most lighthouses, South Hyannis Light was originally built privately. In the 1840s, village resident Daniel Snow Hallett strongly felt that a lighthouse was needed on the south coast of town, along Nantucket Sound, to guide boat traffic in and out of Hyannis waters. He therefore rigged a makeshift lighthouse by moving a tiny shack from an inland location to the bluff. He then placed a whale-oil lantern and a discarded reflector from another lighthouse (Point Gammon) in a window in the loft. His assistant was his young son, Daniel Bunker Hallett. In 1848, Congress agreed with Hallett and appropriated $2,000 for the construction of a real lighthouse on the site. On May 1, 1849, the elder Hallett became South Hyannis Light's first keeper. The lighthouse was decommissioned in 1929. It remained standing, however, as a charming feature of the attached private home. It is still there today. This *c.* 1850 scene is one of the earliest known photographs of the lighthouse. (Courtesy of Alan and Janice Granby.)

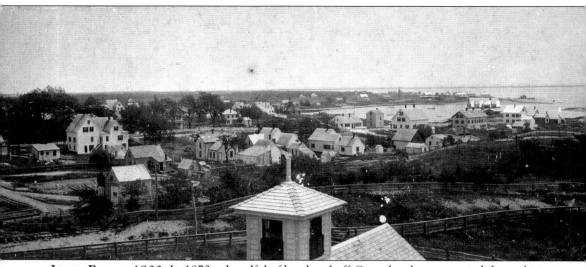

LEWIS BAY, C. 1900. In 1872, a handful of local and off-Cape developers created the ambitious Hyannis Land Company to take advantage of the growing interest in the area as a summer haven. It acquired vast swaths of waterfront land (about 1,000 acres for around $100,000) and soon began touting Hyannis as an idyllic vacation area and selling off lots. The effort was welcomed as a sign that Hyannis was on the brink of enjoying a new era of prosperity and was keeping step with the rest of the world. As streets and lots were being staked, a local newspaper announced, "The dream of many is realized. Hyannis is to be a place of summer resort for the crowded denizens of the city." That building boom lasted until *c.* 1879, when the Hyannis Land Company went bankrupt. (Courtesy of the Hyannis Public Library.)

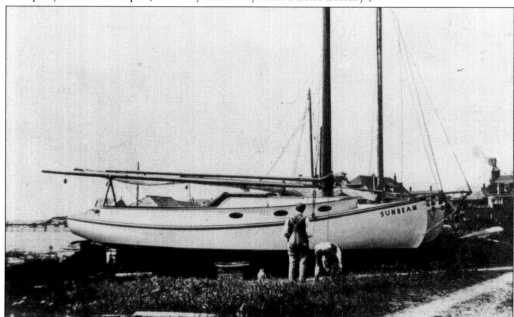

THE CATBOAT *SUNBEAM*. Catboats were once the chief means of transportation on Cape Cod's protected coastal waters. This photograph of the large catboat *Sunbeam* was taken in Hyannis Port. (Courtesy of Elizabeth Mumford Wilson.)

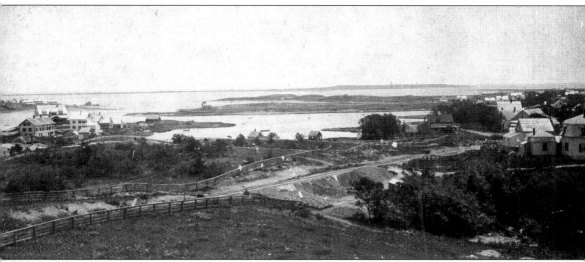

THE VILLAGE BY THE SEA. While Hyannis's Main Street was blossoming into a commercial centerpiece in the 19th century, scenic Lewis Bay was still the village's economic anchor. Named for Jonathan Lewis (an early-18th-century resident), the bay has always been the hub of the town's maritime businesses and recreational life. Like much of the rest of the shore, it has also been the area to which many real estate developers and prospective homeowners have been drawn. (Courtesy of the Hyannis Public Library.)

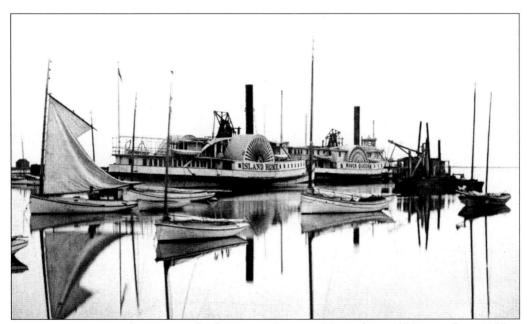

THE ISLAND HOME. The steamer *Island Home* ran between Nantucket and Hyannis from 1855 to 1872, when its mainland port was shifted to Woods Hole, much to the disappointment of Hyannis residents. (Courtesy of the Woods Hole, Martha's Vineyard and Nantucket Steamship Authority.)

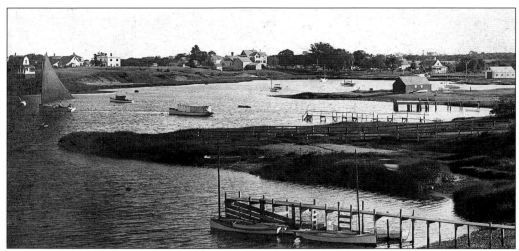

THE HYANNIS INNER HARBOR. Looking west, this *c.* 1900 view shows the Hyannis inner harbor. Much of the land in the center of the photograph on the right was later occupied by the Woods Hole, Martha's Vineyard and Nantucket Steamship Authority. Where the nearer barn stands, in the middle of the photograph, is approximately the site of Baxter's Boathouse Club restaurant. The structure on the extreme right was the Bond family's boathouse. (Courtesy of the Barnstable Patriot.)

EGG ISLAND. Kit Falvey (left) and Gertrude Falvey McKaig are shown on Egg Island *c.* 1900 with two others. This photograph shows the Lewis Bay island before it disappeared. It was a favorite site for clambakes and a popular nesting spot for shore birds. By the 1940s, it had become a mere sandbar and was visible only at low tide when the water receded, revealing a sliver of soft sand—a temporary oasis in the bay for boaters who anchor there to picnic and sunbathe until high tide returns. (Courtesy of the Newman collection.)

THE BISHOP AND CLERKS LIGHTHOUSE. The granite Bishop and Clerks Lighthouse, south of Point Gammon Light in Lewis Bay, was completed in 1858 after more than two years of construction. It marked a treacherous rocky ledge (once a large island where sheep were grazed). The unusual wooden tower on the side housed a fog bell. The first keeper was John Peak, former keeper of Point Gammon. The last was Charles H. Hinckley. It was blown up by the Coast Guard in 1952. (Courtesy of William L. Crocker.)

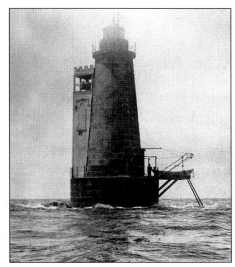

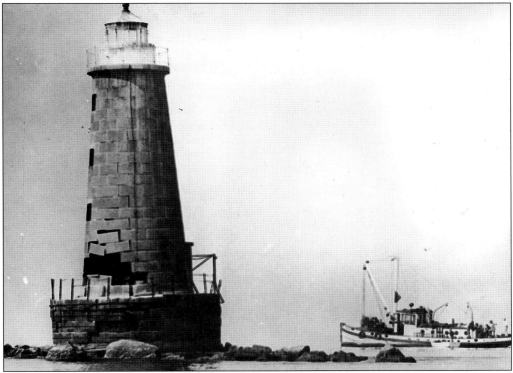

BISHOP AND CLERKS. In 1952, the Coast Guard decided to demolish the Bishop and Clerks Lighthouse, which had stood only as an unlighted day beacon for many years and was deteriorating. In September of that year, the U.O. MacDonald Company of Boston drilled 68 holes in the base of the tower while sandbags were packed around it so it would collapse straight down. With the blast of 200 pounds of dynamite, the lighthouse swayed briefly and then collapsed. The timing of the demolition was supposed to have been kept secret to avoid possible injury to spectators, but word got out and hundreds watched the spectacle from pleasure boats. This is a photograph of the lighthouse just before it was demolished. (Courtesy of the Barnstable Patriot.)

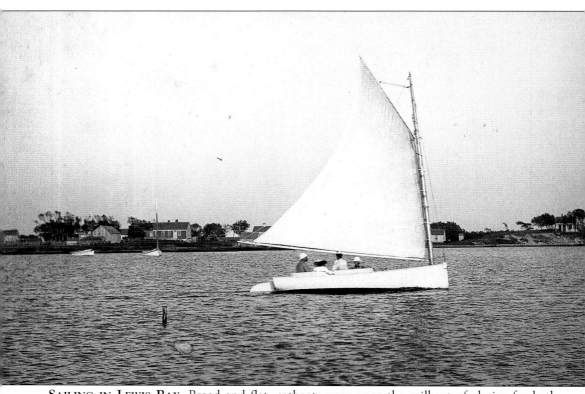

SAILING IN LEWIS BAY. Broad and flat, catboats were once the sailboat of choice for both recreational boaters and fishermen. History is unsure when catboats first appeared, but by the mid-19th century, they were ubiquitous on the waters and shores of Cape Cod and elsewhere. Their stability and versatility made them a favorite among fishermen, scallopers, and clam diggers. They were used as racing boats, and some of the fastest cats were built by Henry Lumbert in Hyannis Port. Many were built by the Crosby family from Osterville. Their popularity peaked in the late 19th century. They were everywhere, even in Currier and Ives prints and in the pages of Cape Cod author Joseph Lincoln's books. By the mid-20th century, they were not as visible on the landscape, but their classic looks have endured and they continued to have many admirers in the sailing community. One memorable catboat was the *Lillian* (not shown), a huge and handsome vessel that was built in Hyannis in 1888 but spent most of its long life on Nantucket. (Courtesy of the Barnstable Patriot.)

THE HYANNIS PORT SHORE, C. THE 1890S. By the end of the 19th century, Hyannis Port was dotted with handsome second homes and was already the swankiest of summer resorts for wealthy families from throughout the northeast. Many came from the Pittsburgh area, where steel had made millionaires. The many windmills seen here were used to pump water from private wells to attic tanks. (Courtesy of the Newman collection.)

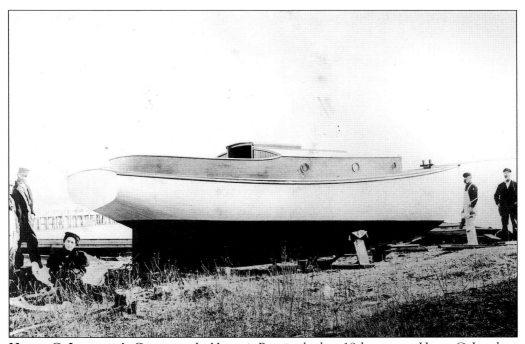

HENRY C. LUMBERT'S CATBOAT. In Hyannis Port in the late 19th century, Henry C. Lumbert built catboats that were known for their exceptional speed. This photograph of the *Joker* was taken on February 25, 1888, as it was nearing completion. In large catboats, enterprising sailors often earned their income by taking parties out for excursions in Lewis Bay and Nantucket Sound, as they do today. (Courtesy of the Newman collection.)

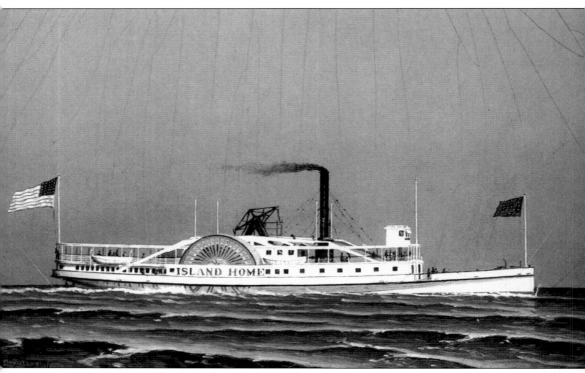

THE *ISLAND HOME*. In 1855, the Nantucket Steamboat Company—which in 1854 had shifted its mainland terminus from New Bedford to Hyannis when the railroad wharf was built—became the Nantucket and Cape Cod Steamboat Company. The new company's first acquisition was the steamer *Island Home*, built as a replacement for the ferries *Telegraph* (also called the *Nebraska*) and *Massachusetts*. Delivered to Nantucket on September 5, 1855, the *Island Home* made its first trip to Hyannis the following day. It weighed 536 tons and was 184 feet long. It ran the route between Nantucket and Hyannis until 1872, when the mainland port for Nantucket ferries was moved to Woods Hole after the railroad reached that village. The *Island Home* was commanded from 1860 to 1891 by Capt. Nathan H. Manter. In 1896, it was sold and turned into a barge. It plied the water in the New York–New Jersey region for the R.B. Little Company of Providence until 1902, when it was damaged by an ice floe off New Jersey and sank. (Courtesy of the Nantucket Historical Association.)

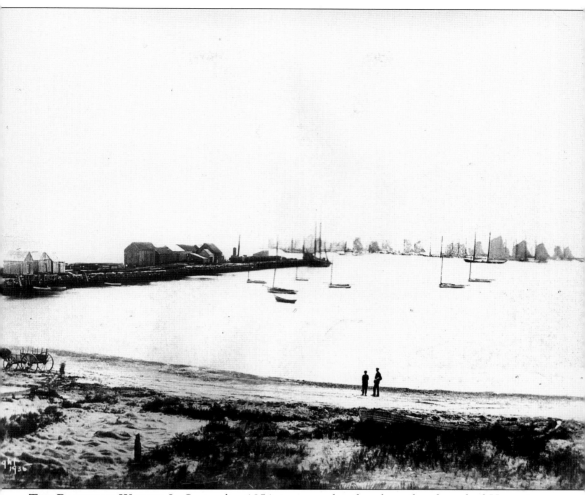

THE RAILROAD WHARF. In September 1854, two months after the railroad reached Hyannis, the tracks were continued down to the south shore so trains could meet passengers and goods arriving on ships from Nantucket and around the world. "We might say that the wharf was the fulfillment of many cherished dreams," wrote columnist Clara Jane Hallett, referring to the goal of establishing a transportation system between Nantucket and the mainland. "Hyannis seemed the best and shortest point of contact, but unless the railroad could be extended through to the waterfront and a line maintained, nothing could be done." When the spur from the depot was complete, the Nantucket Steamboat Company shifted the mainland port from New Bedford to Hyannis. The first trip from Nantucket made to connect with a Hyannis train was made by the steamer *Telegraph* (also called the *Nebraska*) on September 26, 1854. In 1872, the boat line moved the mainland port from Hyannis to Woods Hole, leaving in its wake a disappointed community. This photograph dates from the mid-to-late 19th century. (Courtesy of the Newman collection.)

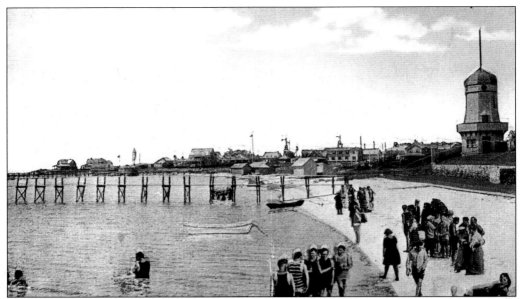

HYANNIS PORT'S EAST BEACH. With crisp new second homes, elegant hotels, sandy beaches, and a placid harbor filled with boats, Hyannis Port was flourishing. An average home rented for about $1,000 for the season c. 1890. In this turn-of-the-century photograph, East Beach is brimming with bathers. The tall structure in the background was built in the 19th century as a water-pumping station. It was called "the Landmark" because sailors at sea could spot it and use it as a navigational aid. (Courtesy of the Newman collection.)

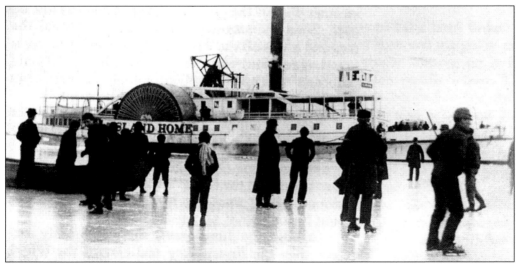

THE *ISLAND HOME* ON ICE. The steamer *Island Home* had more than a few encounters with frozen harbors, most of them off Nantucket. Once, during the steamer's first winter on Cape Cod, Nantucket harbor was so frozen that it had to land at Great Point. (Courtesy of the Woods Hole, Martha's Vineyard and Nantucket Steamship Authority.)

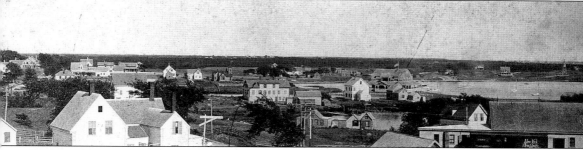

OVER LEWIS BAY. This *c.* 1900 photograph of the village shows the original yacht club, the School Street schoolhouse and a New York, New Haven and Hartford Railroad car. Hyannis became an even more important and inviting port for coasters and packets traveling the New England coast when Congress in 1826 appropriated $10,500 to begin construction of a stone breakwater off Hyannis Port to protect Lewis Bay. It was built in stages and was finally completed many thousands of dollars and many years later. (Courtesy of the Centerville Historical Society.)

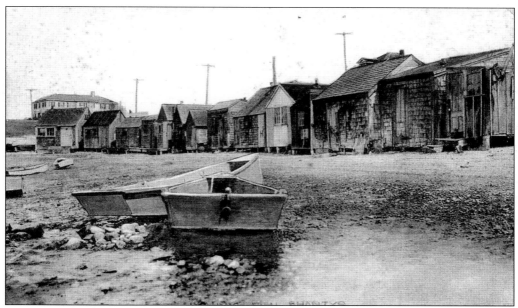

HARBOR FISH SHANTIES. This photograph shows a row of about 15 quaint fishing shanties along Hyannis Harbor that were torn down *c.* 1930 after a handful of residents called them unsightly and waged a campaign for their removal. This area of the harbor came to be called "hardscrabble" *c.* 1900, when a fading maritime economy forced numerous waterfront businesses to close. The shacks were used by fishermen to land and clean their catch. (Courtesy of Alvah W. Bearse.)

19

HYANNIS HARBOR. As the 19th century drew to a close, the era of maritime prosperity was also ending, partly due to the rise of steam-powered boats and the increasing reliance on railroad transportation. The decline of what was once the village's financial mainstay changed the economic landscape in Hyannis. A pall was cast over the once lively harbor while commercial activity in town moved chiefly to Main Street. Thousands of dollars were spent on improvements to the harbor in hopes of reviving maritime interests, including improving the

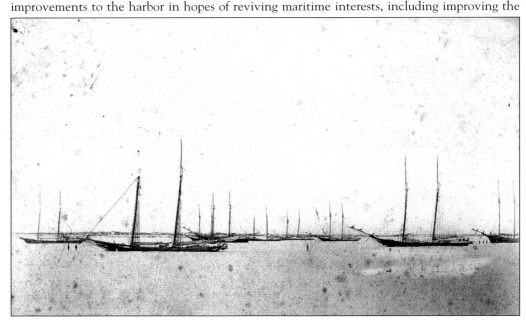

THE SCHOONER VIRGINIA. This photograph, believed to have been taken in 1870, shows Hyannis Harbor frozen over. The ship in the foreground on the right is the two-masted schooner *Virginia*, the captain of which was Nelson Harvey Bearse of Osterville. (Courtesy of the Centerville Historical Museum.)

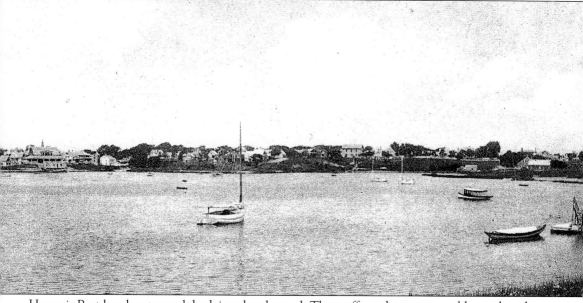

Hyannis Port breakwater and dredging the channel. These efforts, however, could not alter the path of history, and by the early 20th century, it was clear that the glory days of maritime commerce were gone. Nevertheless, the waterfront would again prove to be the gold mine it had always been as it attracted vacationers and summer residents. Pleasure boats and ferries replaced the schooners and clipper ships in Lewis Bay and Nantucket Sound. (Courtesy of the Barnstable Patriot.)

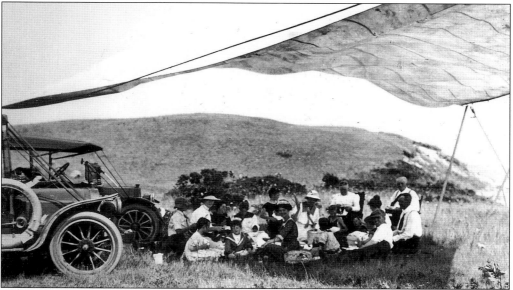

A CLAMBAKE AT FISH HILLS. Back when clams were plentiful, clambakes on the beach were a favorite pastime of Cape Cod families. The Bonds of Hyannis were no different, frequently setting up their picnics on the shore at Fish Hills, an area along Hyannis Harbor. In this photograph, Alice Simmons Bond, a daughter of Capt. Lemuel B. Simmons, is in the chair at the right in the back. (Courtesy of Ed and Sandy Bond.)

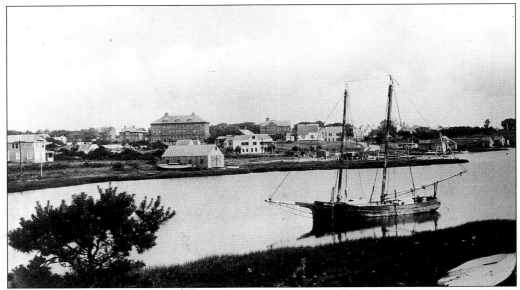

HYANNIS HARBOR. The village of Hyannis grew up around the harbor, as many early residents earned their livings from the sea, from fishing, sail making, boatbuilding, whaling, salt making, and trading. This *c*. 1900 photograph of the Hyannis inner harbor shows the campus of the State Normal School at Hyannis dominating the skyline. The Ocean Street home on the far left was purchased by the Bond brothers, prominent locals, in 1903. (Courtesy of Ed and Sandy Bond.)

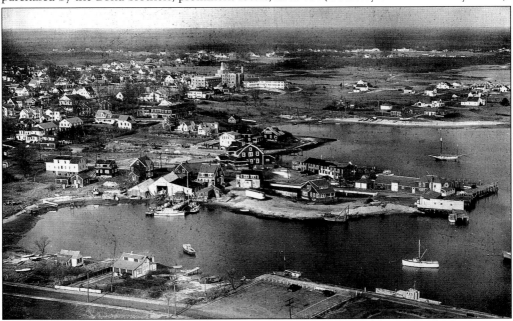

HYANNIS HARBOR MIDCENTURY. This *c*. 1950 photograph of Hyannis Harbor shows how much it changed from the early part of the century. Bismore Park and Ocean Street are in the foreground. The big building in the center off Pleasant Street is probably the old Hyannis Yacht Club. Baxter's Fish Market is at the end of the peninsula on the right. Cape Cod Hospital is at the center toward the top. (Courtesy of the Barnstable Patriot.)

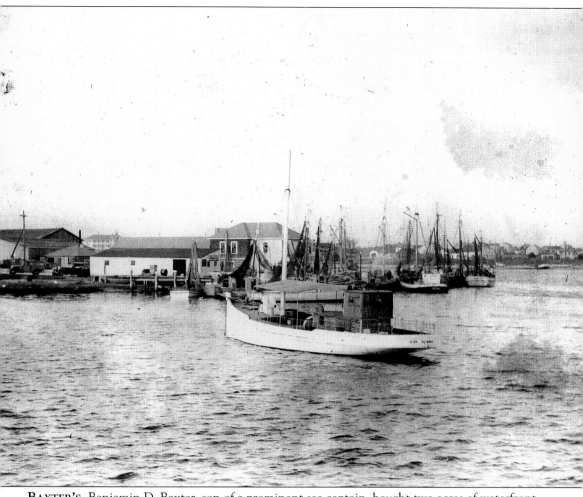

BAXTER'S. Benjamin D. Baxter, son of a prominent sea captain, bought two acres of waterfront land at the end of Pleasant Street in 1919. When they were teenagers, his sons Benjamin and Warren would get out of school early to earn money unloading and packing fish brought in to the wharf on fishing boats like the ones shown here. Warren Baxter in the 1940s went on to establish Baxter's Fish Market there. One summer in the early 1950s, Warren's wife, Florence, bought a deep fryer and began selling fried fish to go next door to the fish market. The small take-out operation in one season was so successful that the family made it a permanent addition to its business and named it Baxter's Fish and Chips. The fish market continued until *c.* 1967, when Barney Baxter, Warren's son, turned it into Baxter's Boathouse Club, a cozy unpretentious restaurant overlooking Hyannis Harbor. With take-out seafood on one side and the restaurant on the other, Baxter's popularity soared and it became a local favorite. Regulars ever since have included the Kennedy family. The lobster boat in the foreground of this view is the *Eva*. (Courtesy of Samuel T. Baxter.)

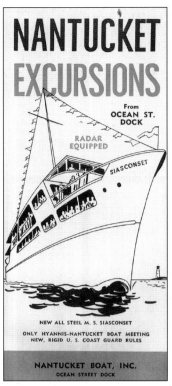

NANTUCKET BOAT INC. The Hyannis Steamship Line Inc., founded in 1946, changed its name to Nantucket Boat Inc. in 1954. It ran ferries from Hyannis to the islands. By 1952, it was running the boats *Kateri-Tek* (later run by Nantucket Express Lines) and *Leprechaun*. In 1954, it bought the *Siasconset*. In 1972, the Scudder family, which had already been running harbor tours and fishing excursions out of Hyannis, bought the business and the name Hi-Line, renamed it Hy-Line, and turned it into a multimillion-dollar enterprise. (Courtesy of Ted Gelinas.)

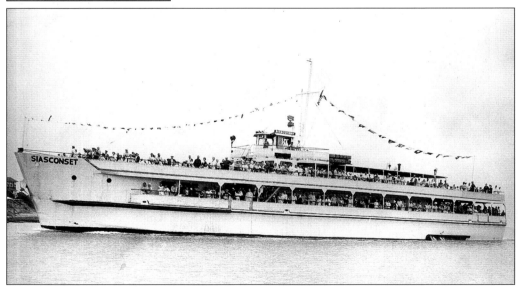

THE SIASCONSET. The ferry *Siasconset*, a former navy landing craft infantry, was purchased by Nantucket Boat Inc., a ferry line, in 1954 and was renovated to carry passengers. Nantucket Boat was located on Ocean Street and competed with the Gelinas family's Nantucket Express Lines. In 1974, the *Siasconset* was sold to the Bob-Lo line on the Great Lakes, where its name was changed to *City of Wyandotte*. It ferried passengers between Detroit and an island amusement park. (Courtesy of Ted Gelinas.)

A Nantucket Express Lines Brochure. In the early 1950s, Joseph T. Gelinas of Hyannis founded the Nantucket Express Lines on Pleasant Street to ferry vacationers to and from Nantucket and Martha's Vineyard. The first vessel was the *Catherine-Tek*, a former yacht. Next, Gelinas started running the *Kateri-Tek*, a former navy vessel. In 1959, he bought the *Martha's Vineyard* from the Steamship Authority. Nantucket Express Lines was discontinued *c.* 1969. (Courtesy of Ted Gelinas.)

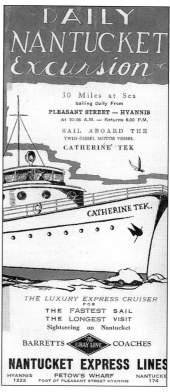

DAILY
NANTUCKET
Excursion

30 Miles at Sea
Sailing Daily From
PLEASANT STREET — HYANNIS
At 10:05 A.M. — Returns 6.00 P.M.

SAIL ABOARD THE
TWIN-DIESEL MOTOR VESSEL
CATHERINE TEK

CATHERINE TEK.

THE LUXURY EXPRESS CRUISER
FOR
THE FASTEST SAIL
THE LONGEST VISIT
Sightseeing on Nantucket

BARRETTS ◆ THE GRAY LINE ◆ COACHES

NANTUCKET EXPRESS LINES

HYANNIS PETOW'S WHARF NANTUCKET
1222 FOOT OF PLEASANT STREET HYANNIS 174

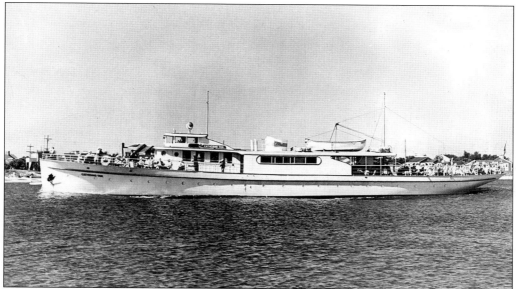

The Catherine-Tek. After Joseph T. Gelinas bought this former yacht in the early 1950s and renamed it the *Catherine-Tek*, he started Nantucket Express Lines, a ferry service between Hyannis and the islands. It was headquartered on Pleasant Street land that Gelinas leased from Edward Petow. The vessel was named for Catherine Tekakwitha, a 17th-century Native American woman who lived in upstate New York. (Courtesy of Ted Gelinas.)

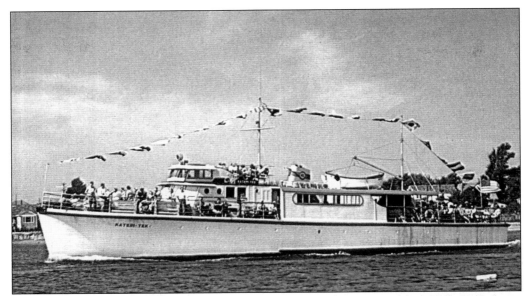

THE *KATERI-TEK*. In the early 1950s, Nantucket Express Lines, owned by Joseph T. Gelinas, began running the *Kateri-Tek,* a former navy air and sea rescue boat, between Hyannis and Martha's Vineyard. Before joining the Gelinas fleet, the *Kateri-Tek* was run to the islands by Gelinas's competitor, the Hyannis Steamship Lines, located on Ocean Street. (Courtesy of Ted Gelinas.)

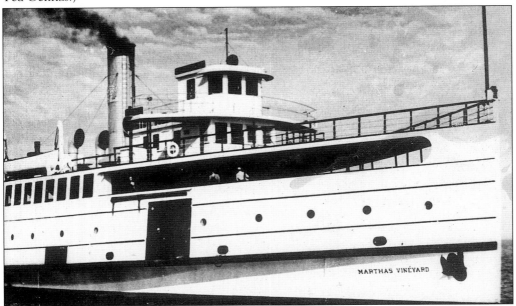

THE *MARTHA'S VINEYARD*. The *Martha's Vineyard* was purchased from the Steamship Authority in 1959 for the bargain price of $25,000 by Joseph T. Gelinas for his Nantucket Express Lines. The *Martha's Vineyard* played a poignant role in Cape Cod history in 1949. That year, James O. Sandsbury, captain of Steamship Authority ferries for more than 40 years, marked his retirement by taking the *Martha's Vineyard* out to the end of the jetties off Nantucket, stepping from the pilot house, and tossing his captain's hat into the water. (Courtesy of Ted Gelinas.)

Two
BUSINESS AND INDUSTRY

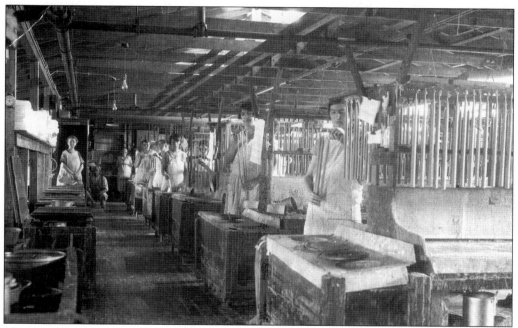

MAKING CANDLES. In the early 1900s, Mabel Kimball Baker (1871–1965) started making bayberry candles in the kitchen of her Main Street home as Christmas gifts. She gathered the berries in the fall from the woods and moors around Hyannis, boiled them to melt off the fragrant pale-green wax coating, and then dipped cotton wicks into the reheated wax as many as 50 times to produce a single candle. They became so popular that she began selling them in her husband's department store in 1909. The following year, orders started coming in from merchants in Boston. Soon, the Colonial Candle Company of Cape Cod was founded (the word *company* was later dropped from the name). Walter D. Baker (1874–1941) left the department store *c*. 1918 to run the new business with his wife. The Bakers soon outgrew their kitchen, and a candle factory was built on Main Street in the early 1920s. At the start of the 21st century, the multimillion-dollar business was still making some of its candles at the original though much enlarged Main Street factory, sending a sweet scent wafting through downtown Hyannis. This 1930s photograph shows employees making candles in the Main Street factory. (Courtesy of Colonial Candle of Cape Cod.)

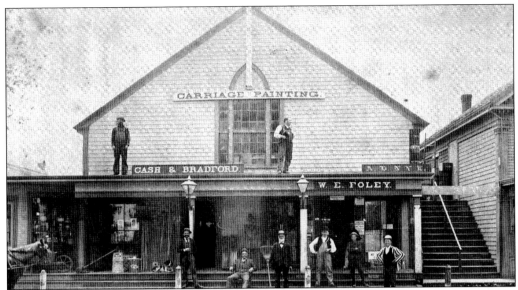

CASH AND BRADFORD. In 1874, while visiting Cape Cod, Pres. Ulysses S. Grant stopped in front of this hardware store at the corner of Main and Pleasant Streets to address townspeople. The building burned down in a spectacular 1892 fire. On the roof are Nelson Robbins (left) and Augustus B. Nye. Below, from left to right, are Myron G. Bradford, Alexander G. Cash, Wendell L. Hinckley, William E. Foley, Joseph B. Snow, and Frank Clifford (the traveling barber). (Courtesy of the Barnstable Historical Society.)

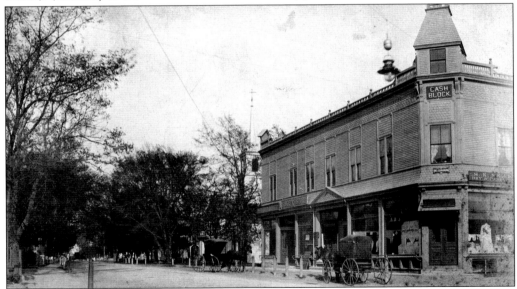

THE CASH BLOCK. Alexander G. Cash built the Cash Block in 1893 at the corner of Pleasant and Main Streets after the Cash and Bradford stove and hardware store and several other shops burned to the ground the year before. The new building housed several businesses, including the hardware store, which was by then owned only by Myron Bradford. There was a bowling alley, pool hall, and barbershop in the basement. On the second floor, Bradford ran an undertaking business and rented living quarters for himself and his family. (Courtesy of Richard Robinson.)

ONCE AND FUTURE OWNERS.
Myron Bradford (right) owned
Bradford's Hardware, located on the
corner of Main and Pleasant Streets.
He also doubled as an undertaker,
running that business on the second
floor of the hardware store for several
decades before selling it to S.N.
Ames and Company. Bradford died
in 1932. In 1933, the hardware store
was purchased from his estate by
Harry Bearse, who had worked there
since he was a teenager. (Courtesy of
Alvah W. Bearse.)

THE PLEASANT STREET SAIL LOFT. This sail loft was owned for many years by Freeman
Hallett. Josiah Hallett (1828–1900), Clara Jane Hallett's father, learned the trade from
Freeman Hallett and eventually bought the business from his widow. The sail loft dates from at
least 1858, when it was pictured on a Hyannis map drawn that year. Hallett later sold the
building to William Reynolds and others for a poolroom. It burned down in 1889. (Courtesy of
the Barnstable Historical Society.)

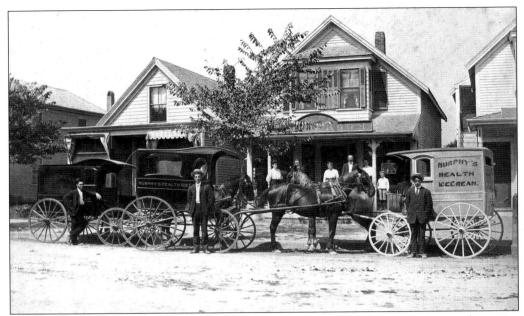

MURPHY'S ICE-CREAM WAGON. William T. Murphy long ran an ice-cream shop and catering business on Main Street. Ice cream and other sweets were also sold around town from horse-drawn wagons. In a 1901 advertisement, the business offered "oysters in every style, ice cream, frozen pudding and sherbets in any quantity at short notice. Fruit, confectionary, cigars, soda and temperance drinks. Also catering." The business was no small outfit; Murphy employed about half a dozen people. (Courtesy of the Barnstable Patriot.)

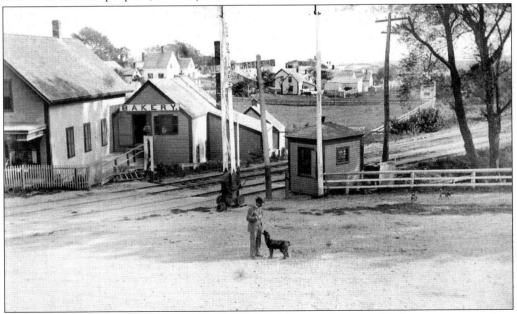

MURPHY'S BAKERY. In the mid-19th century, John Norris's house and bakery were located on Main Street next to the railroad tracks. He later sold the business to the Murphy brothers. (Courtesy of the Barnstable Historical Society.)

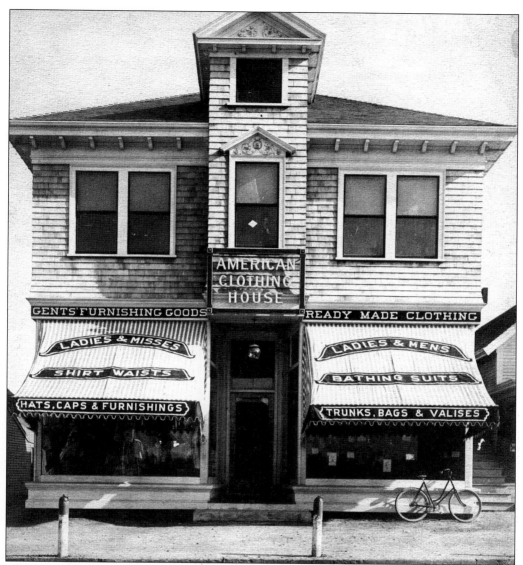

THE AMERICAN CLOTHING HOUSE. The American Clothing House, founded in 1885 by Louis Arenovski (1861–1937), continued as a Main Street mainstay well into the 20th century. Arenovski emigrated to the United States from his native Lithuania as a young man and became a prominent and popular Hyannis merchant and Republican party leader. Soon after arriving on Cape Cod—with only a few dollars in his pocket and a few words of English—he became a peddler, selling clothing door-to-door from a backpack. Diligence and integrity enabled him to purchase a horse and wagon in which he could carry a larger inventory. A short time later, he was selling his goods from a Main Street storefront and soon owned his own building. In time, Arenovski was buying and selling land like a savvy Monopoly player, and his became an influential voice in the development of downtown Hyannis. In their home on North Street, he and his wife, Julia, entertained such politicians as Henry Cabot Lodge and William Weeks, who sought his judgment and advice. This building, which was not the first site of the American Clothing House, was reportedly built in 1898. (Courtesy of the Barnstable Patriot.)

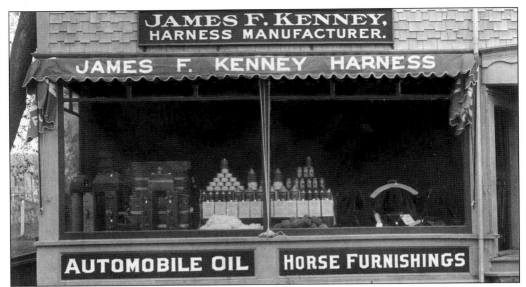

James F. Kenney, Harness Manufacturer. In the early 20th century, when the waning days of horse travel and the dawn of automobile transportation overlapped, the James F. Kenney harness shop on Main Street catered to both. Kenney lived on Ocean Street and was for many years a Barnstable selectman. (Courtesy of the Barnstable Patriot.)

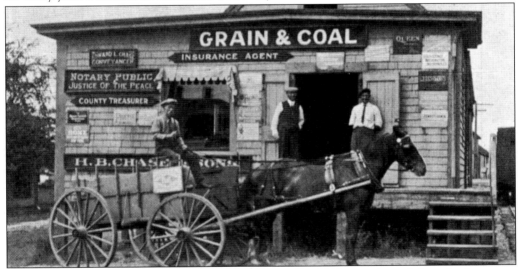

H.B. Chase and Sons Grain, Hay and Coal. In 1848, a grain-and-flour business was started in Hyannis by Heman Chase, who was at the time also running a packet from Hyannis to New York aboard the schooners *Pizarro* and *Yarmouth,* loading the ships with fish for the westward trip and returning to the Cape with goods for local merchants and grain and other supplies for his store. In 1856, David Marchant became his partner. They built a store on the railroad wharf and continued the packet line under the name Chase and Marchant. In 1868, Chase moved the business (by then, selling grain and coal) from the railroad wharf to Main Street across from the depot. He was joined by sons Heman and Clarence. In the early 1870s, another son, E.L. Chase, a prominent Hyannis businessman, was brought aboard and was soon in charge. (Courtesy of the Barnstable Patriot.)

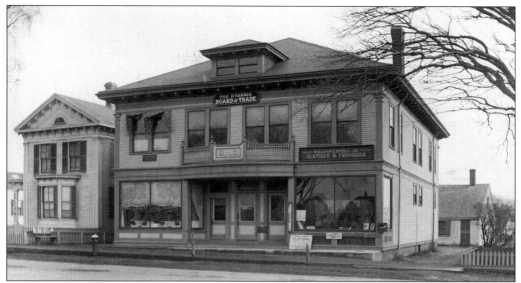

THE HYANNIS BOARD OF TRADE. The Hyannis Board of Trade was organized in 1913 "for the purpose of encouraging the growth, business and prosperity of the villages of Hyannis, South Hyannis and Hyannis Port . . . and to promote social intercourse among its members and provide a suitable place where matters of general interest may be discussed in a non-partisan manner." Early accomplishments included changing the railroad schedule to one more convenient for passengers and helping to establish Cape Cod Hospital. (Courtesy of the Barnstable Patriot.)

THE FIRST NATIONAL BANK OF HYANNIS AND DEPOT SQUARE. The First National Bank of Hyannis (right) opened for business in 1865 in a spare office at the railroad depot. It soon moved above Daniel Crowell's shoe store, where it stayed until 1894, when it moved into a new bank building. It was a national bank until 1916, when it surrendered its federal charter and obtained one from the state as the Hyannis Trust Company. In 1922, it purchased the site of the Masonic temple on Main Street and, in 1923, built a bank building there, which opened in 1924. (Courtesy of the Barnstable Patriot.)

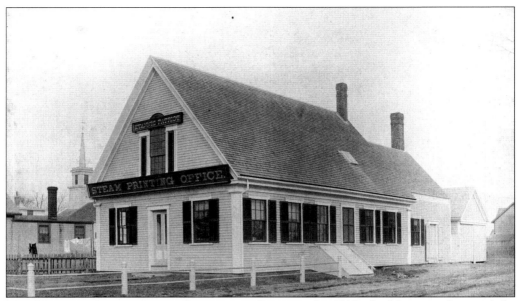

THE HYANNIS OFFICE OF THE *BARNSTABLE PATRIOT*. In 1892, the Hyannis edition of the *Barnstable Patriot* was moved from Barnstable village to the old Freeman Tobey store (then being run as a market by Capt. Allen G. Baxter), on Pleasant Street in Hyannis. In 1906, the newspaper relocated its entire headquarters to the building shown here. The separate Hyannis edition, which began *c*. 1890, was discontinued in the 1940s. (Courtesy of the Barnstable Patriot.)

CAPE COD'S OLDEST NEWSPAPER. Founded in 1830 by Sylvanus B. Phinney (1808–1899), the *Barnstable Patriot* is the oldest newspaper on Cape Cod. Early on, it was printed on a hand press and, later, on a press worked by two men and a crank. In 1859, the first steam press was acquired. Phinney was an outspoken Democrat and unabashedly used his newspaper to espouse his views. The approach sparked lively debates between Phinney and Nathaniel S. Simpkins, a Republican and the publisher of the rival *Yarmouth Register*. (Courtesy of the Barnstable Patriot.)

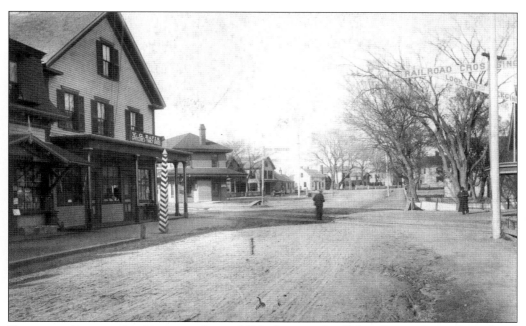

RAILROAD SQUARE. Looking east, this *c.* 1890 photograph of Main Street shows the railroad depot in the center. The buildings at the left in the foreground burned down in the 1904 fire that destroyed a Main Street block. The railroad tracks ran right across the dirt Main Street. After the depot was torn down, in its place was left a traffic island at the intersection of Main and Center Streets. (Courtesy of the Hyannis Public Library.)

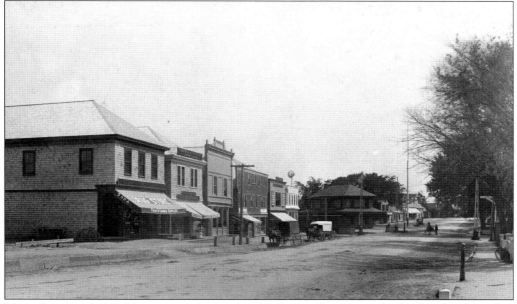

MAIN STREET, 1908. This area on the north side of Main Street was rebuilt after the December 1904 fire that leveled the block. The first store on the left (with an awning) was Megathlin's Drug Store. This is approximately the same view as the photograph above. (Courtesy of the Barnstable Patriot.)

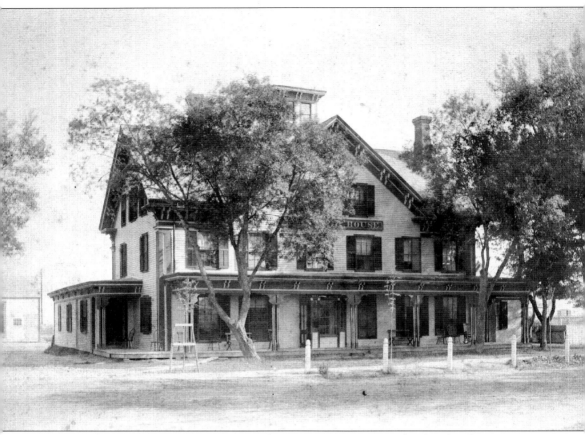

THE IYANOUGH HOUSE. In 1832, when Hyannis was on the brink of emerging as a transportation center of Cape Cod, sea captain Charles Goodspeed had the foresight to build this hotel on the still narrow dirt Main Street. When Yarmouth native Evander C. White bought it in the 1850s, he named it the White House. The Hyannis Land Company bought it from White in 1872 for $6,100 to use as headquarters for its development venture and to accommodate its customers. The company renamed it the Iyanough House. The next owner was Thomas Soule Jr., a successful hotelier from Nantucket who bought it in 1888. It became the Ferguson after Hugh Ferguson of South Braintree bought it in 1915. Throughout the century it existed, it was one of the most popular and busiest hotels in town. It was torn down in 1935, and the offices for the *Cape Cod Times* newspaper were built on the site. This photograph was taken during the time it was called the Iyanough House. (Courtesy of the Barnstable Historical Society.)

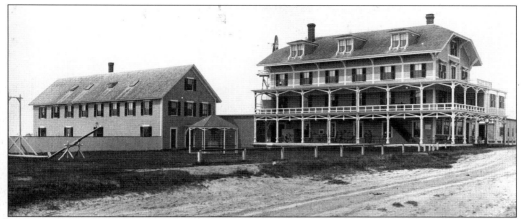

THE HALLETT HOUSE. The 40-room Hallett House hotel was built in Hyannis Port by retired clipper ship captain Gideon Hallett in 1873 to accommodate the growing number of vacationers flocking to the newly discovered Hyannis. For more than three decades, the four-story structure, with its mansard roof, dominated the landscape and was the site of many of the neighborhood's social events. It burned down in 1905. (Courtesy of the Barnstable Patriot.)

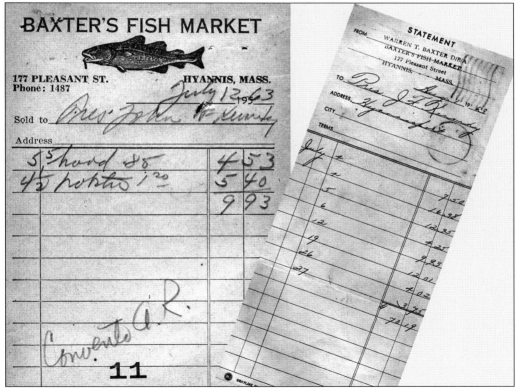

THE PRESIDENT'S RECEIPTS. Even as president, John F. Kennedy was a regular customer of Baxter's Fish Market when he was on Cape Cod. These are receipts for orders taken in July and August 1963. The president frequently had Baxter's seafood delivered to him and his guests in Hyannis Port. The fish market was founded by Warren Baxter, one of Benjamin D. Baxter's sons. (Courtesy of Samuel T. Baxter.)

NUMBER 400
PRISCILLA PEARL
BANGLE BRACELET
$4.50

PRISCILLA LABORATORY
HYANNIS MASS.

NUMBER X
14K WHITE GOLD
CLASP WITH
SAPPHIRE STONE
$25.00

PRISCILLA LABORATORY
HYANNIS
MASS.

PRISCILLA PEARLS. Ralph Bodman was one of several local businessmen who made artificial pearls from the scales of herring in the early 20th century. He called his product Priscilla Pearls and sold the jewelry he made in Priscilla Pearl Shoppes on Main Street in Hyannis and on Martha's Vineyard. He was a competitor of both Edward I. Petow and Benjamin D. Baxter.

PEARL COATING. The thick syrup that formed the lustrous veneer on artificial pearls made in Hyannis in the early 20th century was made from the scales of herring pulverized and mixed with solutions in enormous vats. The fish were scaled on scaling benches with steel knives. This bottle of the translucent coating was from the supply used by pearl maker Ralph Bodman.

Three

HYANNIS SOCIETY

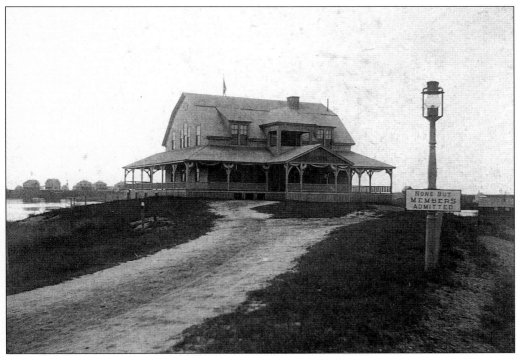

THE ORIGINAL HYANNIS YACHT CLUB. The original Hyannis Yacht Club was founded in 1895 at the suggestion of Allan P. Eagleston, proprietor of the upscale New York Store on Main Street. The clubhouse, shown here, was built at the foot of Pleasant Street by local builders N. Bradford and Sons. The interior included a bowling alley, billiards room, elegant ladies' parlor, and a second-floor banquet hall with balconies on two sides. In August 1896, a gala dedication and housewarming took place that included music from a brass band, a banjoist, and a classical quartet. H.B. Winship of Dennis was the commodore; Lindsey N. Oliver of Hyannis was president; and Eagleston was the vice president and chairman of the board. In 1919, the building was bought by Russian immigrant Edward I. Petow and Herman Finkelstein. Petow was a chemist and artist who founded an artificial-pearl industry in Hyannis. He used the building as his factory and built living quarters for his family on the second floor. It was torn down in the mid-20th century. (Courtesy of the Centerville Historical Museum.)

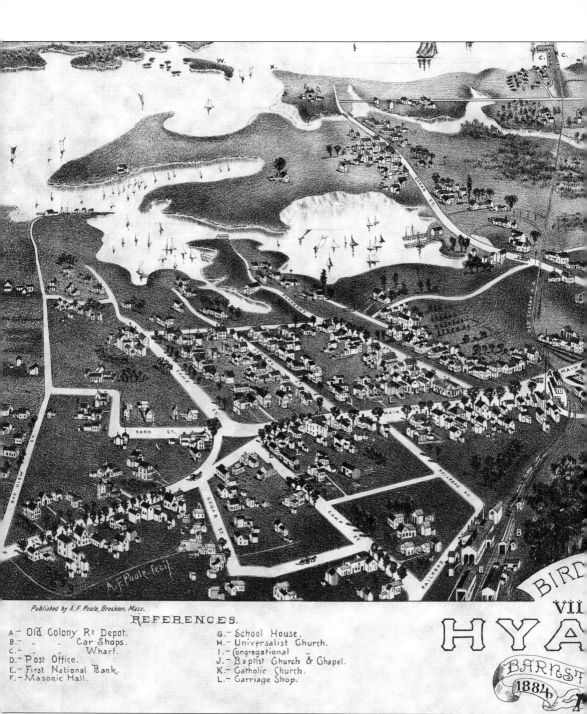

A.F. Poole fecit.

REFERENCES.

A.— Old Colony Rx Depot. G.— School House.
B.— " " Car Shops. H.— Universalist Church.
C.— " " Wharf. I.— Congregational "
D.— Post Office. J.— Baptist Church & Chapel.
E.— First National Bank. K.— Catholic Church.
F.— Masonic Hall. L.— Carriage Shop.

BIRD
VII
HYA
BARNST
1884

A MAP OF HYANNIS, 1884. This drawing shows the streets of downtown Hyannis and some structures as they looked in 1884. It shows the post office on Main Street (D), which was destroyed in the fire of 1904; the small Catholic church (K) on Ocean Street (later Barnstable Road), which became St. Francis Xavier Church when it was moved to South Street; the "twin schoolhouses" (G), at the west end of Main Street and another schoolhouse on School Street;

40

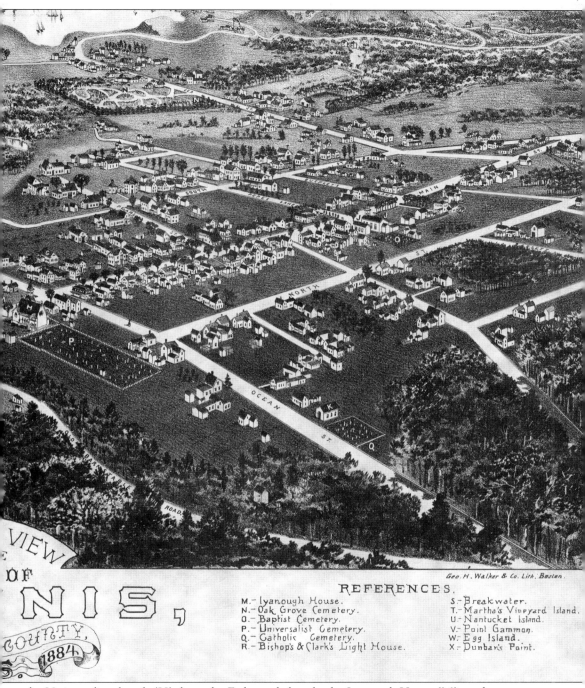

VIEW OF NIS, COUNTY, 1884

REFERENCES.

M.– Iyanough House.
N.– Oak Grove Cemetery.
O.– Baptist Cemetery.
P.– Universalist Cemetery.
Q.– Catholic Cemetery.
R.– Bishop's & Clark's Light House.

S.– Breakwater.
T.– Martha's Vineyard Island.
U.– Nantucket Island.
V.– Point Gammon.
W.– Egg Island.
X.– Dunbar's Point.

the Universalist church (H), later the Federated church; the Iyanough House (M), at the corner of Main and Ocean Streets; the Bishop and Clerks Lighthouse (R); and the railroad wharf (C), with South Hyannis Light nearby. In 1884, the railroad wharf was still busy; about 8,000 tons of coal, 1.5 million feet of lumber, and 115,000 bushels of grain were offloaded there. Some 1,650 sailing vessels and 150 steamers came into Hyannis that year. (Courtesy of William L. Crocker.)

41

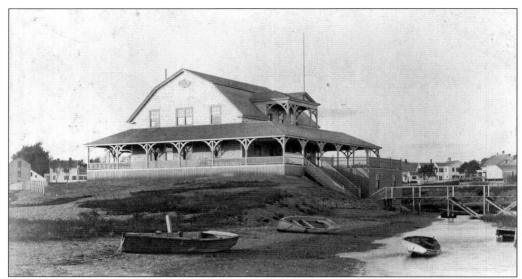

THE ORIGINAL HYANNIS YACHT CLUB. The original Hyannis Yacht Club, built in 1896, had a wraparound veranda that was 20 feet wide on the water side, a gambrel roof, balconies, dormers, and a handsome porte cochere. "The architect must have had in mind the old adage, the first impressions are lasting, for he has lavished his artistic skill here to make the first impression a good one," said the *Patriot* newspaper. (Courtesy of Cape Cod Community College.)

EARLY YACHTERS. Members of the original Hyannis Yacht Club pose in September 1897. They are, from left to right, George W. Hallett, Howard Crowell, Ira Bassett, Charles Crocker, Simeon Lewis, William Lewis, Henry B. Winship, and George F. Baker. Yacht club members were instrumental in persuading the state to pay for a major Hyannis Harbor dredging project around the turn of the century. (Courtesy of the Hyannis Public Library.)

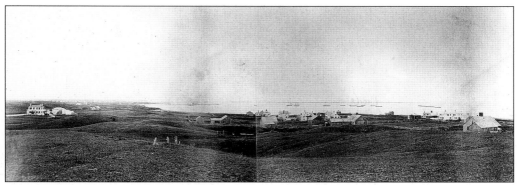

HYANNIS PORT, C. 1860. This is believed to be one of the earliest known photographs of Hyannis Port. Like much of the Cape, the landscape here was nearly devoid of trees in part because so many had been cut down for fuel and for lumber to build boats and homes. Others were toppled by hurricanes. Furthermore, much of the land was farmed. (Courtesy of Elizabeth Mumford Wilson.)

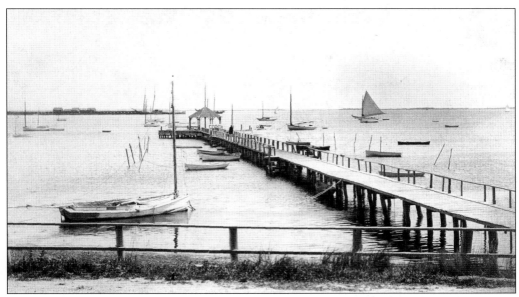

THE HYANNIS PORT YACHT CLUB. The Hyannis Port Yacht Club was created in the early 1900s. On August 3, 1908, the *Patriot* reported, "The Hyannisport [sic] Yacht Club will have its annual amateur regatta on Friday of this week at 10:55 a.m." The report went on to say, "This promises to be the leading event of the season in these waters." This *c.* 1900 photograph shows the pier that the club uses. (Courtesy of the Barnstable Historical Society.)

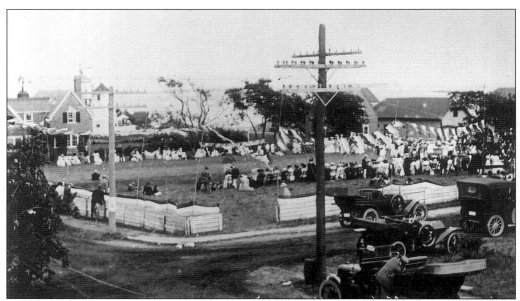

A GYMKHANA. Gymkhanas were festive outdoor community fairs often held as fundraisers. The second annual gymkhana in Hyannis Port, shown here, took place in August 1910 to raise money for Hyannis Port's Village Improvement Society. Most of the fair took place on a vacant lot next to the Irving Avenue property that future president John F. Kennedy purchased in 1956. (Courtesy of the Newman collection.)

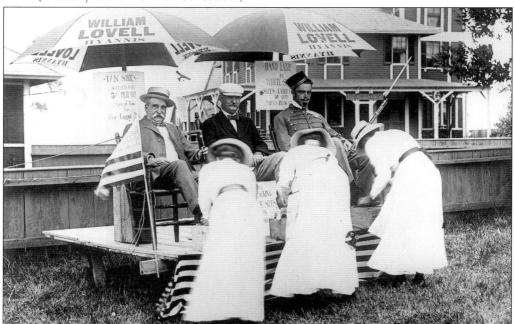

GETTING A SHOESHINE AT GYMKHANA. At the shoeshine stand during Hyannis Port's 1910 gymkhana, Samuel McCluny (left), George M. Wright (center), and Harry Loutrel are treating their shoes to a cleaning. The polishers are Marion and Constance Scudder and Amary King. The price for a shoeshine that day was 5¢ per foot. (Courtesy of the Newman collection.)

MAIN STREET, UNDER A CANOPY. Main Street was once shaded by a canopy of trees. Most were wiped out by commercial development and by Dutch elm disease. In 1968, the *Patriot* reported that 50 elms, estimated to be 75 to 125 years old, would be cut down in Barnstable because of the scourge. Tree warden Donald Coombs explained that the encroachment of macadam smothered roots and cut off supplies of water and food. "The principal cause of this situation is the continuous encroachment over the years of macadam or hard-topping by many builders and developers," Coombs said. The lack of nutrients had left the trees more vulnerable to Dutch elm disease. Coombs added, "Between the ravaging by hurricanes and the invasion of Dutch Elm disease, our town has lost several hundred old elms in the past 30 years. And that doesn't count those healthy ones that have been cut down by developers and builders to make room for a little more parking space or a few square feet of building." Looking west, this *c.* 1890s view shows Main Street from the Baptist church. (Courtesy of the Barnstable Patriot.)

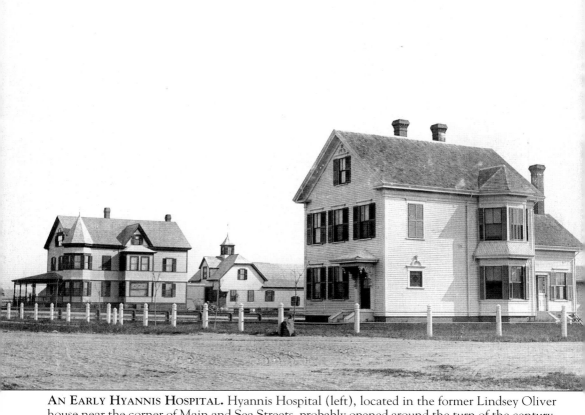

AN EARLY HYANNIS HOSPITAL. Hyannis Hospital (left), located in the former Lindsey Oliver house near the corner of Main and Sea Streets, probably opened around the turn of the century. It appears to have been a small, part-time hospital—but a busy one. Even members of the District Nursing Association, which ran it, acknowledged that it was not a full-fledged hospital. In 1919, in the *Patriot* newspaper, the association complained that during August of that year, three trips to Boston were made so that patients could be treated at hospitals there and that "any one of these patients could have been cared for here just as well if we had had a local hospital, and with greater comfort to the patient and with less expense." Hyannis Hospital probably closed around the time Cape Cod Hospital opened in 1920. (Courtesy of the Barnstable Historical Society.)

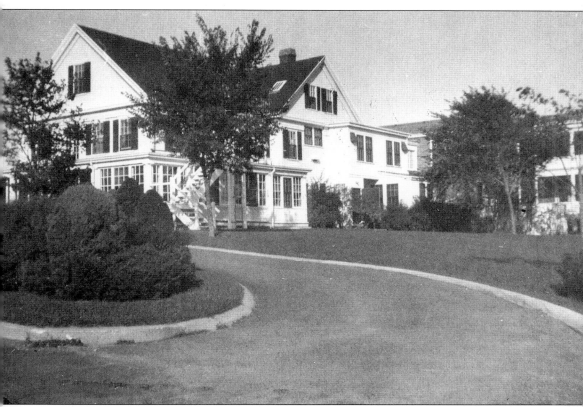

CAPE COD HOSPITAL. In February 1919, two sailors who were rescued from a grounded Belgian bark were in urgent need of medical care. Heavily bandaged, with their hands and feet frozen, they huddled in a baggage car of a train, waiting in Hyannis to begin the trip to Boston, where the nearest hospital was located. The sight was witnessed by another passenger, businessman Charles L. Ayling, a Boston banker who had a summer house in Centerville. Ayling realized that Cape Cod needed a hospital of its own and, within days, started a campaign to make that happen. Cape Cod Hospital, with 14 beds, opened on October 4, 1920, in Dr. E.F. Gleason's former summer home, overlooking Lewis Bay. The three-story residence had been bought from Gleason for $35,000. Four years later, the new Charles Lincoln Ayling Wing was opened, bringing the number of beds at the hospital to 45. Additions and renovations have continued ever since. At the start of the 21st century, the hospital had 218 beds and its emergency room alone treated more than 70,000 patients annually. This photograph shows the original Gleason house and the newer Ayling wing (right). (Courtesy of Cape Cod Hospital.)

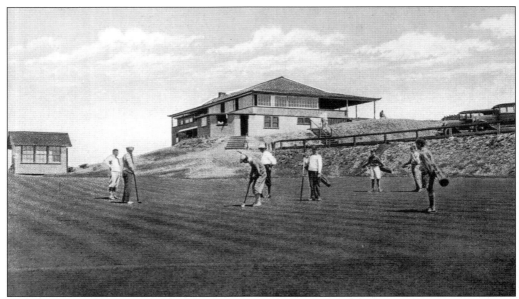

GOLFERS AT THE HYANNISPORT CLUB, C. 1910. Founded in 1897 when the popularity of golf was soaring, the Hyannis Port Golf Club changed its name to the Hyannisport Club in 1909. It was quickly the social center of the neighborhood. The first nine holes were designed in 1897 by John Reid, the legendary Scottish golf course architect who helped introduce the sport to the United States. Tennis courts were later added. (Courtesy of the Newman collection.)

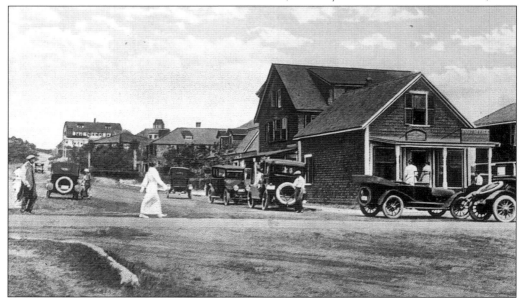

THE HYANNIS PORT POST OFFICE. Throughout the 19th century, the post office in Hyannis Port was housed in different locations in the neighborhood. It moved c. 1900 into its permanent location in the heart of the hamlet, next to the news and candy store at the corner of Wachusett and Longwood Avenues. Early Hyannis Port postmasters included David Scudder, Frederick Scudder, Toilston Phinney, Wendell L. Hinckley, and George D. Makepeace. (Courtesy of the Newman collection.)

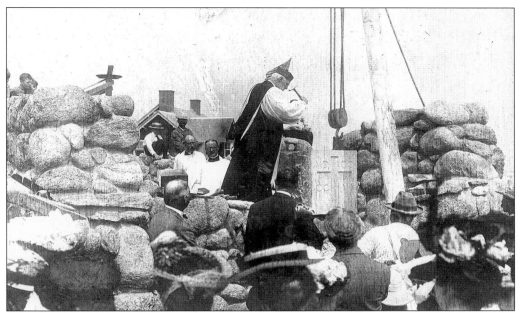

ST. ANDREW'S BY THE SEA. In August 1906, Bishop Cortland Whitehead of Pittsburgh presided at the laying of the cornerstone of St. Andrew's by the Sea in Hyannis Port. The Episcopal church was designed by architects Clark and Russell of Boston. St. Andrew's was organized in 1900. Before the construction of the church, the congregation worshiped in a former Hyannis Port schoolhouse that had been renovated into a chapel. When they outgrew that, they gathered in the Universalist church on Main Street in Hyannis. (Courtesy of the Newman collection.)

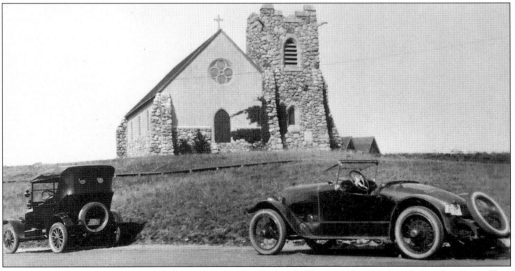

A CHURCH WITH A VIEW. High on Sunset Hill, the fieldstone St. Andrew's by the Sea offers a breathtaking view of Hyannis Port, Squaw Island, and Nantucket Sound. The Episcopal church was built on land donated in 1904 by Augusta Whittemore of Cambridge. Construction began in 1906 and was completed in 1911. It was consecrated in August of that year by Rt. Rev. William Lawrence, bishop of Massachusetts. (Courtesy of the Newman collection.)

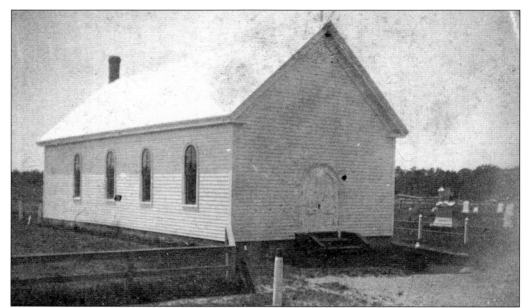

THE FIRST ST. FRANCIS XAVIER CHURCH. St. Francis Xavier, a Catholic church, was originally built in 1874 on Barnstable Road (then called Ocean Street) near the corner of Louis Street. At the time, it was called St. Patrick Church. It was moved *c.* 1903 to South Street, where it was widened and remodeled to accommodate a growing congregation. The name was changed to St. Francis Xavier because of an increase in the Cape Verdean population on Cape Cod and the desire to avoid the impression that the church was just for the Irish. (Courtesy of Erin O'Neil Moore.)

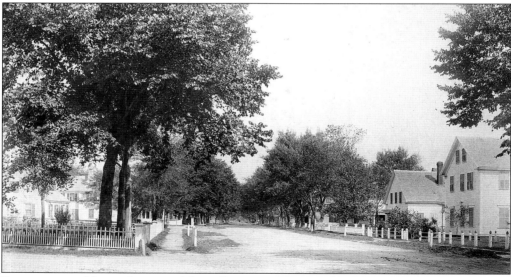

RESIDENTIAL MAIN STREET. Main Street was once almost entirely residential from approximately Ocean Street west to the end. The business center in the 19th century was from Ocean Street east to the railroad depot. The homes, many built by retired wealthy sea captains, were replaced by stores in the mid-20th century. Main Street is shown in a view looking east from the Baptist church. (Courtesy of the Barnstable Patriot.)

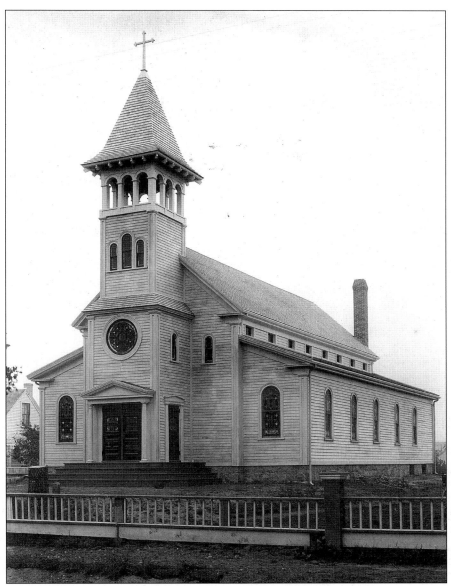

ST. FRANCIS XAVIER. This Catholic church on South Street began as a Spartan chapel built on Barnstable Road (then Ocean Street) in 1874. It was moved to South Street *c.* 1903 and was enlarged. When the church was renovated again in 1916, four Ionic columns were added to the front entrance and the building was lengthened to double the seating capacity. An east wing was added in 1946, and a west wing in 1953. Renovations completed in 1999 brought the seating capacity to 1,200. The Kennedy family worshiped here for many years, and all four Kennedy brothers served as altar boys. The altar in the main church was given by the Kennedy family as a memorial to Joseph P. Kennedy Jr., the president's brother, who was killed in World War II. When he was president, John F. Kennedy and his wife sat in the second pew from the front. The secret service occupied the first and third rows. Maria Shriver, the president's niece, and Arnold Schwarzenegger were married here in 1986. This photograph is believed to have been taken in the early 20th century. (Courtesy of the Barnstable Patriot.)

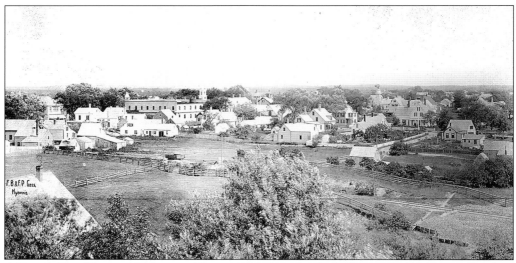

A BIRD'S-EYE VIEW OF HYANNIS. This *c.* 1900 photograph, looking east, was reportedly taken from the Hyannis Training School, near the corner of Ocean and South Streets. The large building on the left is the Cash Block, on the corner of Pleasant and Main Streets. Notice the railroad tracks on the lower right, running toward the railroad wharf. This photograph is the first half of a panorama with the photograph on the opposite page. (Courtesy of the Barnstable Patriot.)

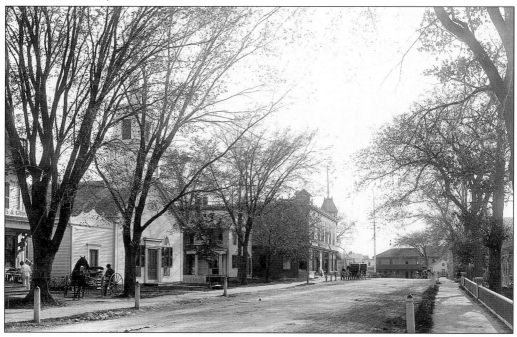

MAIN STREET'S EAST END. This *c.* 1900 view shows the Congregational church (left), the 1893 Cash Block (center), and the railroad depot (right of center). After it merged with the Universalist church, the Congregational church building became a social and recreational center for village children. It later became Church Bell Apartments. (Courtesy of the Barnstable Patriot.)

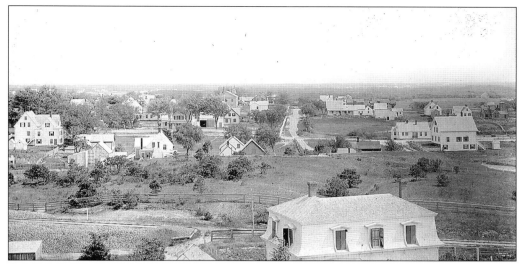

AN AERIAL VIEW OF PLEASANT STREET. Many of the homes in this *c.* 1900 photograph, which may have been taken from the Hyannis Training School, are on Pleasant and School Streets. Lewis Bay is out of frame to the right. The dirt road running up the center of the picture later became South Street. The tall building in the distance to the left of the road is the School Street schoolhouse. The photograph is a continuation of the picture on the opposite page. (Courtesy of the Barnstable Patriot.)

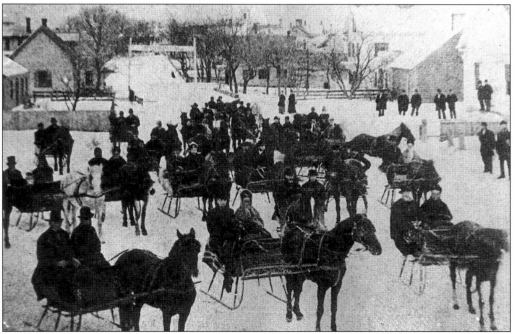

SLEIGH RIDING ON MAIN STREET. This photograph of townspeople gathered on Main Street in horse-drawn sleighs was taken in the late 19th century. In 1897, the *Patriot* reported, "The sleighing is so splendid. Everybody with a horse and sleigh lives up to the opportunity, while the crowds who do not drive assemble on the street." The sign over the street is a railroad crossing warning. The depot is just visible at the far left. (Courtesy of the Centerville Historical Museum.)

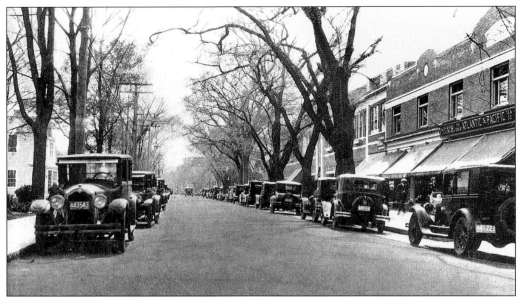

THE A & P ON MAIN STREET. This early-20th-century photograph of Main Street shows the A & P (right), one of the first chain stores on the street. For many years, the grocery store was managed by John Eyre, who eventually left to start his own grocery store on Sea Street, where he lived. Another employee, Wesley Coleman, left to open a grocery store on Park Square. (Courtesy of the Barnstable Patriot.)

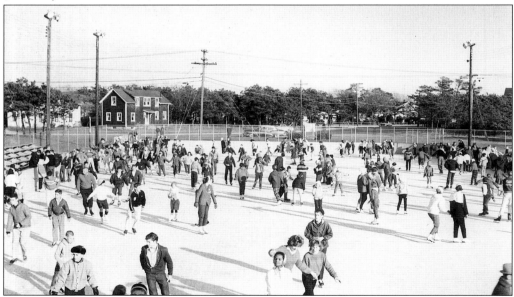

THE LT. JOSEPH P. KENNEDY JR. MEMORIAL SKATING RINK. This public ice-skating rink on Bassett Lane was given by the Kennedy family in memory of eldest child Joseph P. Kennedy Jr. (John F. Kennedy's brother), who was killed in 1944 while serving in World War II. The rink was opened in November 1957. At its dedication, Selectman Victor F. Adams said, "As long as this facility is used, Lieutenant Joseph P. Kennedy will not be forgotten." (Courtesy of Gordon E. Caldwell.)

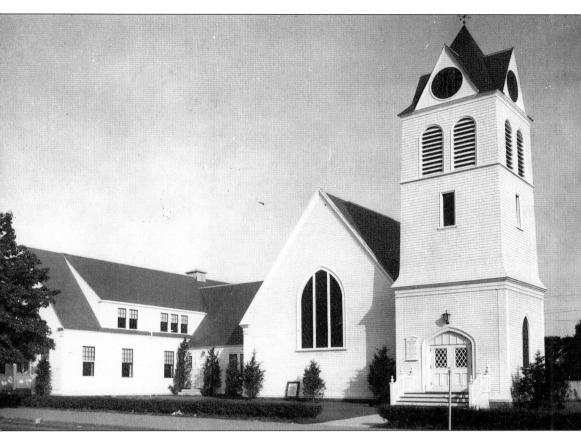

THE FEDERATED CHURCH. The Federated Church of Hyannis was founded in 1917 when the Universalist and Congregational societies, both on Main Street, merged. Shortly thereafter, Rev. Sarah A. Dixon was called to become the minister of the new Federated Congregation (as it was called then), and she began her seven-year tenure on July 1, 1917. As the Congregational church was too small to accommodate the growing congregation, all agreed that worshipers would gather in the Universalist church permanently. The two churches kept their separate names for four years after merging. Then, in 1921, the new church was incorporated under the name Federated Church of Hyannis. This Universalist building (which later became the Federated church) was built in 1905 to replace one that burned to the ground in the 1904 Main Street fire. It was designed by architect Frank L. Paine. The construction contract was awarded to Savery and Fish of Cotuit, the lowest of 15 bidders. Construction of a new church to replace this one was completed in 1958. (Courtesy of the Federated Church.)

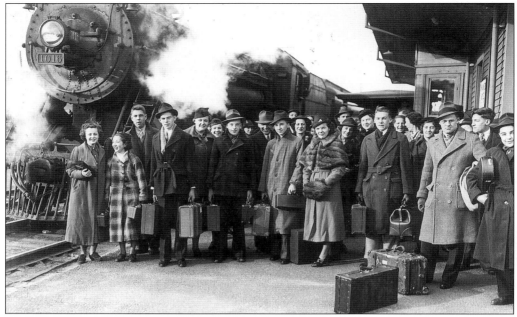

YOUNG MUSICIANS ARRIVE AT THE DEPOT. In March 1937, Hyannis was host to more than 600 high school musicians from throughout New England who came to town for a music festival. The visitors were the toast of the town and of the press. These musicians are posing after having arrived at the railroad station. (Courtesy of the Barnstable Patriot.)

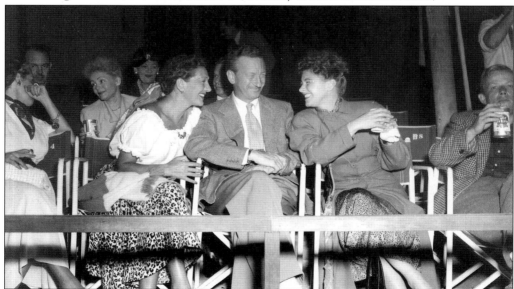

THE CAPE COD MELODY TENT. The Cape Cod Melody Tent was founded as the Cape Cod Music Circus in 1950 by Richard Aldrich (center, at the Cape Cod Music Circus in 1950), already owner of the Falmouth Playhouse and the Cape Playhouse, and his wife, actress Gertrude Lawrence (left). The opening show, held on July 4, 1950, was *The New Moon*. In its early days, the summer stage was located on North Street. It later moved to West Main Street. (Courtesy of the Barnstable Patriot.)

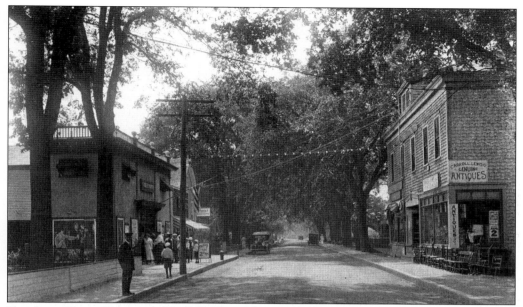

THE IDLE HOUR THEATRE. The Idle Hour Theatre (left), on Main Street near Ocean Street, opened in 1912. The year-round movie theater was a popular destination for Hyannis residents of all ages until it burned down on Christmas Eve 1971. A 1915 magazine advertisement listed the price of admission as 10¢. After it was sold to Interstate Theatres in the late 1930s, it was called the Center Theatre. (Courtesy of the Barnstable Patriot.)

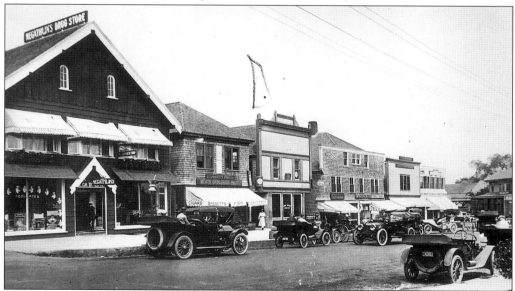

MEGATHLIN'S. Opened in the 19th century, Megathlin's Drug Store was a fixture on Main Street until the mid-1920s, when proprietor Charles Megathlin sold it to the Liggett's drugstore chain. Megathlin was a prominent and wealthy businessman who lived on Main Street, a few blocks from his store, and served the town in many volunteer capacities, just one of which was first president of the Cape Cod Chamber of Commerce, created in 1921. (Courtesy of the Newman collection.)

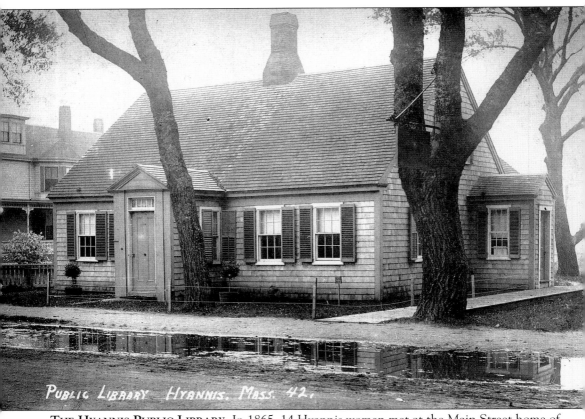

PUBLIC LIBRARY HYANNIS. MASS. 42.

THE HYANNIS PUBLIC LIBRARY. In 1865, 14 Hyannis women met at the Main Street home of R. Ford Baxter, Capt. Sylvester Baxter's widow, and quietly created the Hyannis Literary Association, the forerunner of the Hyannis Public Library. The women began to raise money for books with food and craft sales. The library's first bookshelves were in Freeman Tobey's General Store on Pleasant Street, later the site of the *Barnstable Patriot* newspaper. Early on, the library was open only to subscribers, or members of the Hyannis Library Association, who paid an annual $1 fee to borrow books. In 1908, after at least two additional moves, the library settled into its permanent location, a small shingled house at 401 Main Street (shown here). The house had been owned by Otis Loring in the 1830s and doubled a post office, as Loring was the postmaster. In the 1840s, the house was sold to Capt. Samuel Hallett and his wife, Dorcas. In 1908, the Halletts' heirs sold it to Hyannis Port resident James Otis, who paid $2,500 for it and promptly gave it to the library as its new home. In 1909, Ora Adams Hinckley, who was widowed the previous year, accepted the position of first full-time librarian. Hinckley held the post for 34 years. Sylvester Baxter Jr., the son of the captain and the library founder, became a well-known Boston journalist. (Courtesy of the Centerville Historical Museum.)

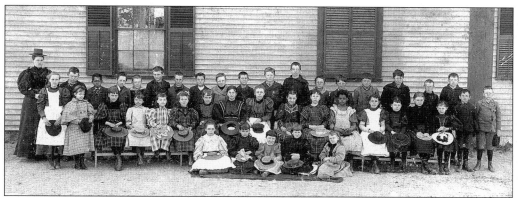

SCHOOLCHILDREN, 1896. These Hyannis schoolchildren were probably the last to be educated in this unidentified school building. In January 1897, Hyannis students through the eighth grade were all transferred to the new Hyannis Training School on Ocean Street. (Courtesy of Erin O'Neil Moore.)

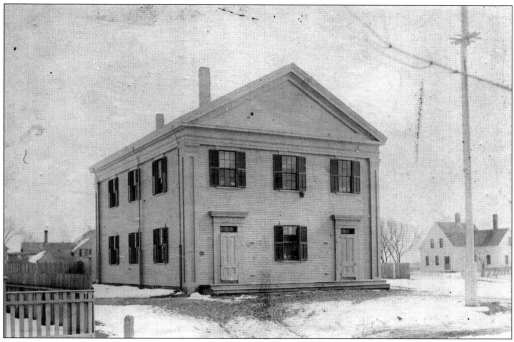

THE SCHOOL STREET SCHOOLHOUSE. This schoolhouse was built on School Street sometime before 1858. A map of Hyannis in 1858 shows it situated near the intersection of School Street and the path that later became South Street. Students of different grades were educated here during the 19th century. It was the high school from the early 1890s until 1905, when a new high school was built off South Street. The building was sold at auction in October 1905 to Charles C. Crocker, who paid $1,300. The building later became a nursing home. (Courtesy of the Barnstable Historical Society.)

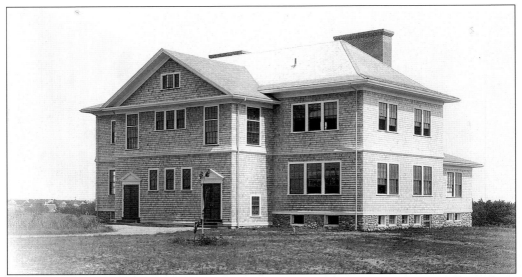

THE OLD BARNSTABLE HIGH SCHOOL. Barnstable graduated its first class of (just two) high school students in 1883 but did not have its own high school building until this one was built in 1905 off South Street at a cost of $12,621. Prior to its construction, the town's high school students went to the clapboard school building on School Street. In the 1920s, the school pictured here was replaced by another high school, built on the same site. (Courtesy of the Barnstable Patriot.)

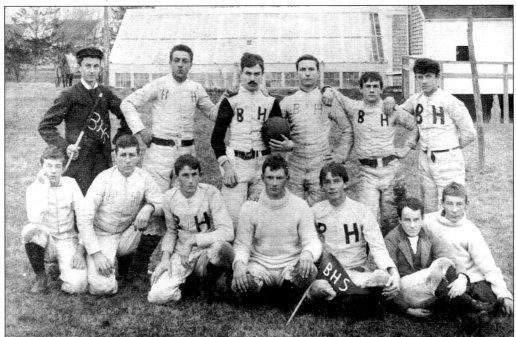

THE BARNSTABLE HIGH SCHOOL FOOTBALL TEAM, 1894. Pictured are Eben A. Thacher, H. Clifton Bradford, ? Bowen, Harold Hinckley, Thomas Horne, Peter Pineo Chase, Forest Mores, Eddie Crowell, Frank G. Thacher, Henry Snow, William A. Johnson, William Collins, and Frank O'Neil. (Courtesy of the Hyannis Public Library.)

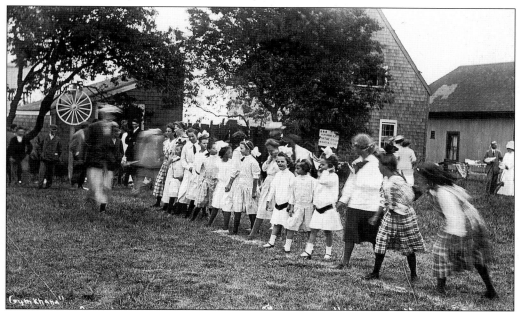

GYMKHANA. At Hyannis Port's 1910 gymkhana, local children competing in a race line up at the starting line, waiting eagerly for the signal to take off. (Courtesy of the Newman collection.)

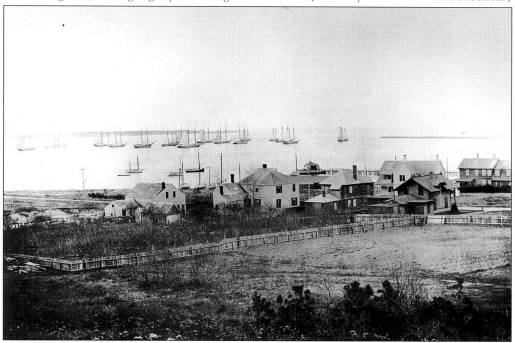

HYANNIS PORT TAKES SHAPE. Hyannis developed slowly until the 1870s, when tourism began to emerge. By the 1920s, another building boom was under way as the area experienced a surge in popularity as a summer haven. Not everyone was pleased. One Boston newspaper editor in 1925 called it the "Floridization of Cape Cod." This photograph of Hyannis Port Harbor was taken in 1899. (Courtesy of the Newman collection.)

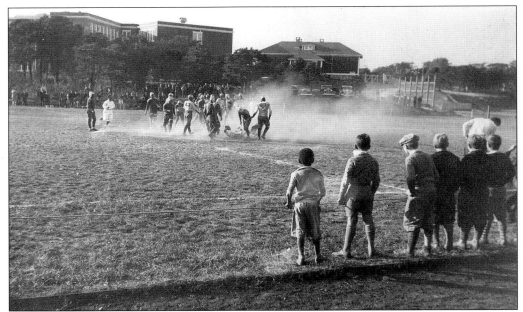

A BARNSTABLE HIGH SCHOOL FOOTBALL GAME, 1935. This photograph shows the Barnstable High School Angel Guardians, as the team was called, in the midst of a game with a visiting team. In the background, the 1905 high school (right) is next to the newer high school, built in the 1920s. The earlier school was eventually torn down. (Courtesy of Sean Walsh.)

HELPING ON THE HOME FRONT. During World War II, Boy Scouts Myron Bettencourt (left) and Robert Sherman were runners for the town, ferrying messages on bicycle or on foot wherever they needed to go. This photograph was taken on Main Street in front of what was then the town hall, a building that later became the John F. Kennedy Hyannis Museum. Police chief Harry Laws is in the foreground. (Courtesy of Robert and Priscilla Sherman.)

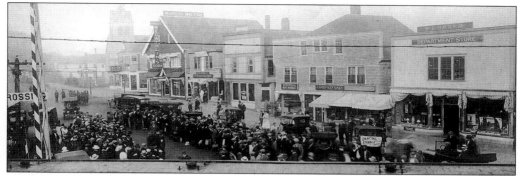

LEAVING FOR WORLD WAR I. In September 1917, young residents of Cape Cod gathered in Hyannis to board the train for Camp Devens in Ayer. On the day before they left, a farewell rally was held for them in Hyannis. The *Patriot* newspaper reported, "All other sections of the country are going through the experience of parting with their young men and Cape Cod and the islands would not be exempt." (Courtesy of the Centerville Historical Museum.)

A WELCOME HOME PARADE. On July 4, 1919, townspeople threw a welcome home celebration for its residents who served in World War I. A parade marched down Main Street; patriotic banners bedecked downtown; and the town held a baseball game, a clambake, and an elegant ball. Four Barnstable men who went to that war did not return. Carleton T. Harlow was killed in action in France; Ralph B. Hoxie was killed accidentally at the Chatham Naval Station; and William W. Taylor and Paul H. Sherman Jr. died of disease in France. (Courtesy of Alvah W. Bearse.)

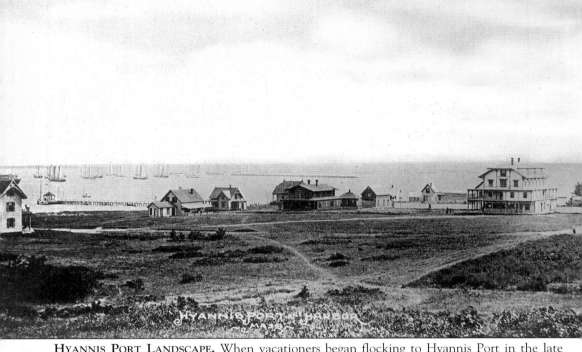

HYANNIS PORT LANDSCAPE. When vacationers began flocking to Hyannis Port in the late 19th century, they were welcomed by most locals but not by all. While many saw the newcomers and their new homes as harbingers of economic prosperity, others packed up and left. In 1872, the *Patriot* newspaper reported, "The Port was never more crowded with visitors than at the present time. Every boarding house is full and many are daily turned away who would like to be accommodated. What is needed beyond anything else to fill out and complete the Land Company's operations is a hotel at the Port. This essential ought not to be overlooked. By another season at the farthest it should be attended to. People will come to the Port, that is a fixed fact. Let them find suitable accommodations and they will remain there during the summer." The following year, the Hallett House hotel (right) was built. Several others followed, including the Port View Hotel and the Pavilion (later the Milan House). The house to the right and rear of the Hallett House was owned by Capt. Wendell L. Hinckley. (Courtesy of the Newman collection.)

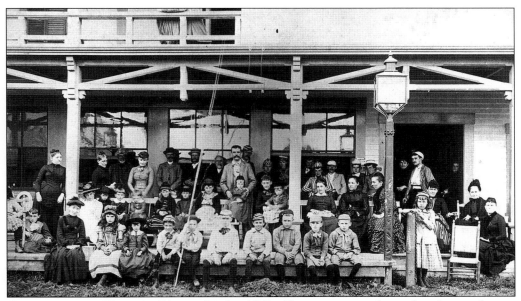

GUESTS AT THE HALLETT HOUSE. In the 1870s, Hyannis was in the midst of an ambitious campaign marketing the region to tourists and would-be summer residents. Hotels like the Hallett House went up to accommodate the new visitors. Built by Capt. Gideon Hallett (1817–1892), the hotel opened for business in Hyannis Port in 1873. For more than three decades, it was the site of many of the neighborhood's social events. It burned down in 1905. This *c.* 1890s scene shows a gathering of unidentified hotel guests. (Courtesy of the Newman collection.)

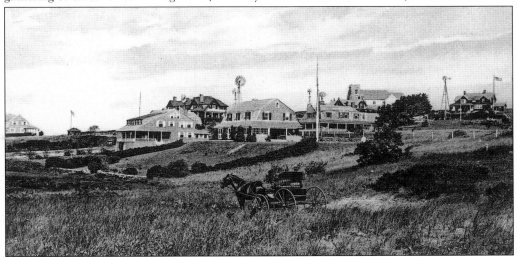

HYANNIS PORT. The discovery of Hyannis Port as a summer haven for wealthy families began when the Hyannis Land Company, a syndicate of developers, was created in the winter of 1871–1872. The *Patriot* newspaper reported in 1872, "Lumber is being carted in considerable quantities to the various lots on which cottages are to be built; carpenters are busy at work framing the buildings and . . . visitors have already made their appearance to oversee the work of making for themselves a summer home." Although the Hyannis Land Company went bankrupt *c.* 1879, it had begun a steady flow of vacationers that has never stopped. (Courtesy of the Newman collection.)

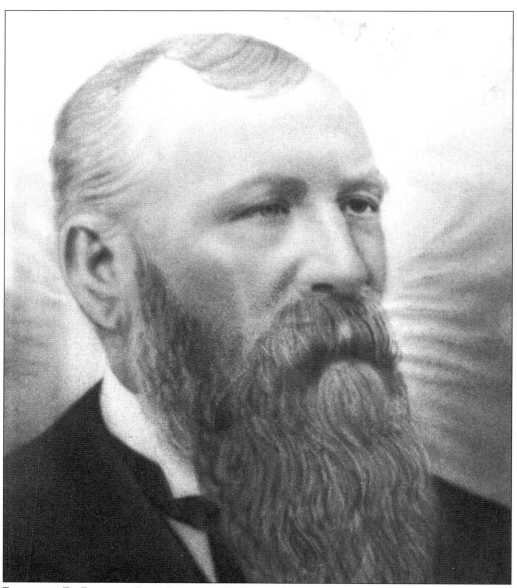

BENJAMIN D. BAXTER. Capt. Benjamin D. Baxter (1833–1897) was a deepwater captain who commanded the *Gerard C. Tobey*, the *John N. Cushing*, and the *Alden Besse*, among other ships. He went to sea at about age 12, which was typical for Cape Cod boys of his day, and stayed on ships for 30 years. He served in the Civil War, was a trader on the coasts of India and China, and ran a ship chandlery in Belgium. He later returned to Hyannis and lived with his family on Main Street. Born in Yarmouth, Baxter was one of 15 children. He married twice. His first wife, who died at a young age, was the daughter of Evander White, owner of the White House hotel. Baxter's second wife was Elizabeth A. Webber of England. They had five children, two of whom, Marjorie and Annie, were born aboard the *John H. Cushing* off India. In 1919, his son Benjamin bought land at the end of Pleasant Street where the venerable waterfront restaurant Baxter's Boathouse Club was later established. This portrait hangs in the restaurant. (Courtesy of Samuel T. Baxter.)

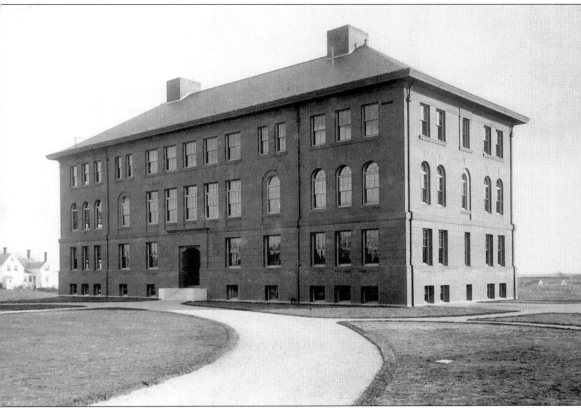

THE STATE NORMAL SCHOOL AT HYANNIS. Normal schools were schools for men and women studying to become teachers. The State Normal School at Hyannis was founded in 1897 and was closed in 1944. The name was changed to State Teachers College at Hyannis in 1932, probably to better reflect what it was. Furthermore, beginning in 1933, graduates held college degrees. In 1894, the state legislature authorized the establishment of a normal school on Cape Cod and, with eager support and active lobbying from locals, chose Hyannis as the location. The state imposed two requirements on the town as requisites for locating a normal school there: that the town buy land for the campus and that a training school (or elementary school for Hyannis children) be built next to the normal school to provide a training ground for the student teachers. Both conditions were enthusiastically met by townspeople. The first class of 32 students was welcomed to the school in September 1897. The school's first principal was William A. Baldwin, who stayed at the helm until 1924. (Courtesy of the Barnstable Patriot.)

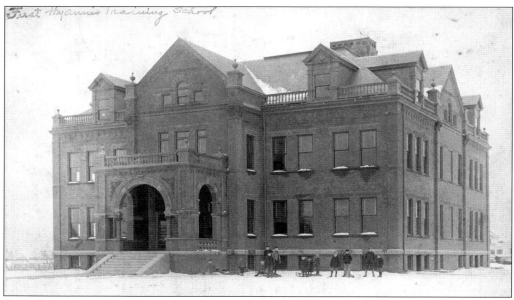

THE FIRST HYANNIS TRAINING SCHOOL. The Hyannis Training School, an elementary school, was built in 1895 at a cost of $23,000 on Ocean Street to provide a setting in which prospective teachers at the normal school next door could practice and observe. This school, however, burned to the ground in January 1896 just weeks after its completion. A new one was immediately built. (Courtesy of the Hyannis Public Library.)

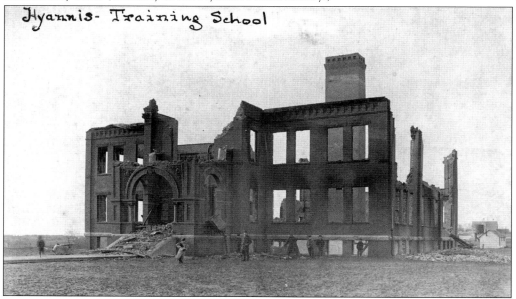

FIRE DESTROYS THE HYANNIS TRAINING SCHOOL. The new Hyannis Training School burned down on the evening of January 24, 1896, just three weeks after it had been dedicated and two weeks after classes had begun. Students were sent back temporarily to local school buildings that had been emptied by the completion of the training school. The children would return to a rebuilt training school in January 1897. The building had cost about $23,000 to build but was insured for only $14,000. (Courtesy of the Hyannis Public Library.)

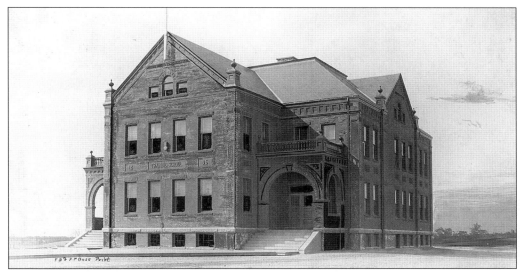

THE HYANNIS TRAINING SCHOOL. The Hyannis Training School, an elementary school, was built on Ocean Street at a cost of $26,000 to replace the training school that had burned to the ground in January 1896 just weeks after completion. The second school's architectural design was somewhat different from the first. Classes started in January 1897 with an enrollment of 204 students through grade eight. There were only three large classrooms on each floor. It was built of West Barnstable bricks. (Courtesy of the Barnstable Patriot.)

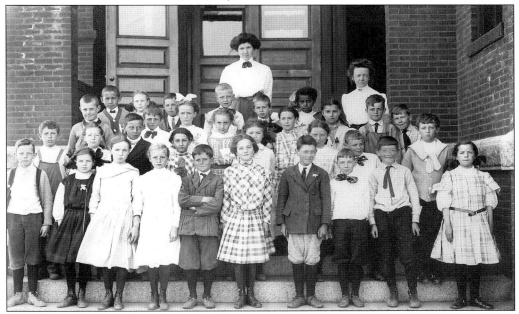

A SCHOOL PHOTOGRAPH. Pupils attending the Hyannis Training School pose at the building c. 1909. Some of the children are, from left to right, as follows: (first row) Horatio Bond, Georgia Cook, two unidentified, Parker Sears, two unidentified, Richard Harris, unidentified, and Louise Murphy; (second row) two unidentified, John Brooks, Elizabeth Boody, Virginia Paine, and the rest unidentified. The teacher on the right is identified as Miss Gregg. (Courtesy of Ed and Sandy Bond.)

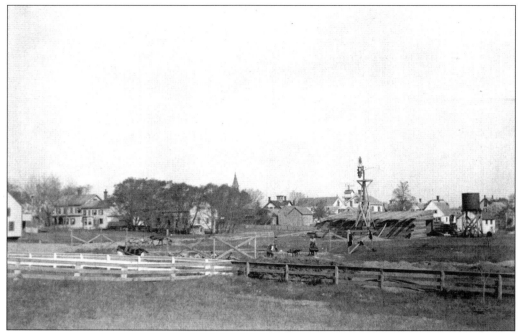

BREAKING GROUND FOR NEW DORMITORIES. This was the site on which the dormitory building accompanying the State Normal School at Hyannis was built. These were not Spartan dormitories. The rooms appear to have been both comfortable and attractive. "It is said that the furnishings of this dormitory are far superior to any boarding school in Massachusetts," reported the *Patriot* when the school opened. The four-story brick building later became the Barnstable school administration building. (Courtesy of the Barnstable Historical Society.)

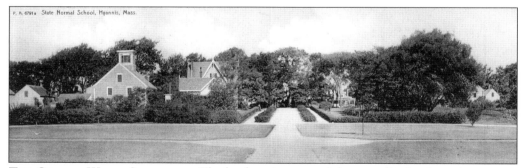

THE CAMPUS WAS A SHOWPIECE. The landscaping around the normal school was impressive. Paths were bordered by flowering shrubs, and flower beds brightened the 12-acre campus. In time, the brick buildings were covered with ivy because it was a tradition for the graduating class to plant ivy on commencement day. Lawns were impeccably tended, and in spring and summer, students walked the grounds each morning, plucking dandelions to impede their proliferation. This photograph was taken looking toward Main Street, with the normal school at the photographer's back. (Courtesy of the Barnstable Patriot.)

70

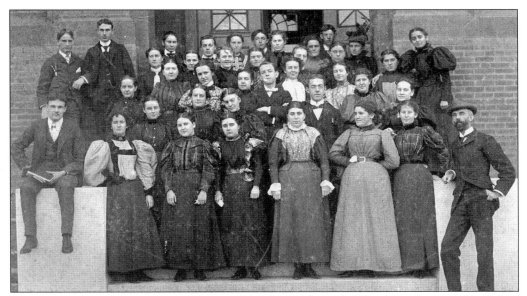

THE NORMAL SCHOOL'S FIRST CLASS. The State Normal School at Hyannis opened in September 1897 with a class of about 32 students, among them future lawyer John Bodfish. Members of the first class, all Cape Codders, pose here on November 22, 1897. The first class was peppered with old Cape Cod names like Crocker, Hinckley, Nickerson, and Crowell. Principal William Baldwin is shown in the first row at the far right. (Courtesy of the Hyannis Public Library.)

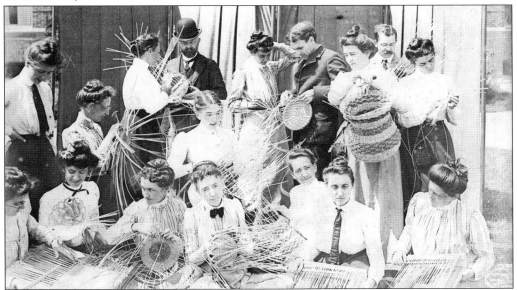

A LESSON IN BASKETRY. In this 1902 photograph, summer session students at the normal school are learning to make baskets. William A. Baldwin, the school's principal, felt that traditional education at the time was not sufficiently practical to prepare students for everyday life. He introduced a number of nonacademic courses to the school's curriculum. Due to that philosophy, children at the Hyannis Training School tended gardens on campus, growing flowers and vegetables. (Courtesy of Cape Cod Community College.)

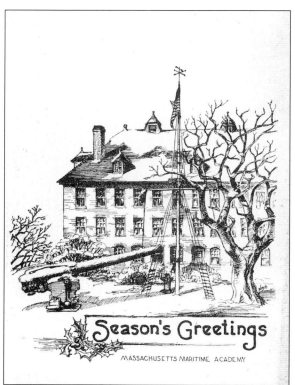

Season's Greetings

MASSACHUSETTS MARITIME ACADEMY

THE MASSACHUSETTS MARITIME ACADEMY. The Massachusetts Maritime Academy was housed in the teachers college from 1942 to 1949. In 1942, the training ship *Nantucket* was condemned, and because the ship was also the dormitory, the cadets had nowhere to live. Another training ship would not be provided until after World War II, and it was therefore decided to move the Massachusetts Maritime Academy from Boston to the teachers college and to share the facility with students there. The academy left Hyannis because it obtained a new training ship, and Hyannis Harbor was too shallow for it. (Courtesy of Robert and Priscilla Sherman.)

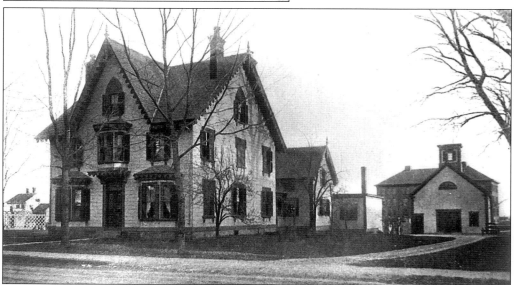

THE RESIDENCE OF THE NORMAL-SCHOOL PRINCIPAL. This Main Street home, once owned by Capt. Owen Bearse, was purchased by the state in 1897 as a residence for the principal of the normal school. William A. Baldwin, the school's first principal, moved here in the summer of that year. Notice the normal school in the background. This later became the site of the Hyannis post office. Bearse (1812–1887) was a deepwater captain who commanded the schooner *Splendid*. (Courtesy of Alvah W. Bearse.)

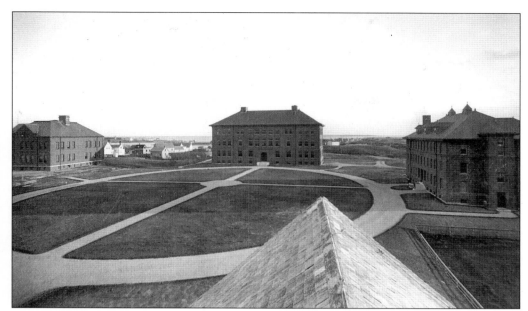

THE CAMPUS OF THE NORMAL SCHOOL. This is the campus of the State Normal School at Hyannis shortly after its completion. The Hyannis Training School is on the left; the normal school is in the middle; and the dormitory is on the right. Hyannis Harbor is in the background. The cornerstone for the normal school was laid in April 1896. In it was put a time capsule, a copper box containing such items as newspapers, coins, photographs, business cards, town reports, and voting lists. (Courtesy of the Barnstable Patriot.)

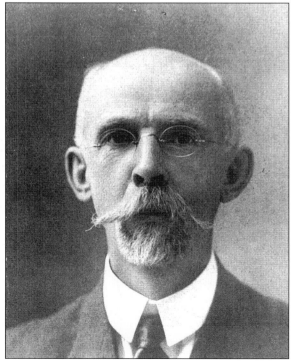

WILLIAM A. BALDWIN. William A. Baldwin was the first principal of the normal school, serving from 1897 to 1924. He graduated from Oswego Normal School in New York, studied philosophy at Cornell, and studied psychology and pedagogy at Harvard. Baldwin was thought to be ahead of his time philosophically. His approach to the education of both future teachers and children at the Hyannis Training School emphasized the importance of physical activity and of students' health, happiness, and self-reliance along with academics. (Courtesy of Alvah W. Bearse.)

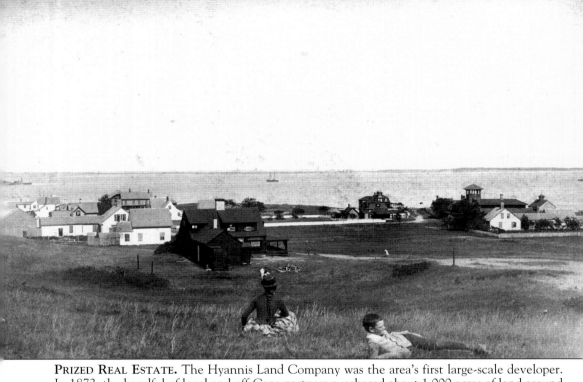

PRIZED REAL ESTATE. The Hyannis Land Company was the area's first large-scale developer. In 1872, the handful of local and off-Cape partners purchased about 1,000 acres of land around and near the water from Dunbar's Point at the end of Ocean Street to the Centerville line for about $100,000. It included much of Hyannis Port. They began ambitiously marketing lots to wealthy would-be summer residents happy to be part of the blossoming of Hyannis as a vacation destination. The business designed street plans, staked lots, built homes, and put up hotels to accommodate the new vacationers and prospective homeowners. It bought Evander White's Main Street hotel (called the White House), changed the name to Iyanough House, and set up its headquarters there. One of the landowners who sold property to the Hyannis Land Company was the town of Barnstable, which gave the developers all of Squaw Island in Hyannis Port for the grand sum of $200. This early landscape of Hyannis Port shows some of the prime waterfront real estate eyed by the land company. (Courtesy of the Hyannis Public Library.)

Four

MEMORABLE
TOWNSPEOPLE

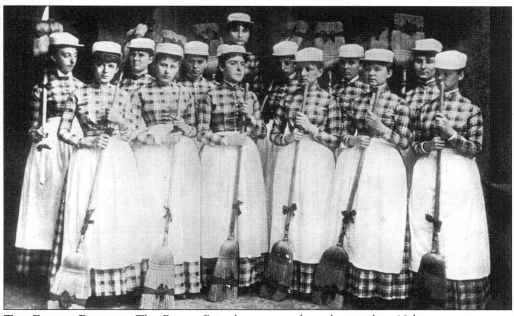

THE BROOM BRIGADE. The Broom Brigade seems to have been a late-19th-century amateur theatrical troupe of Hyannis women. In June 1888, the players, armed with brooms and dustpans, put on a variety show at the Masonic hall. The event was held to raise money for streetlights in Hyannis. The ticket price was 25¢. The theme of the performance, according to the *Patriot* newspaper, was "to sweep away the clouds which threaten to dim, if not entirely obscure, our street-lights." The newspaper went on to encourage attendance of the upcoming show, saying that "all our citizens who wish for more light and desire the street lamp to be kept burning" should go. The brigade also performed a skit about women's rights. At the end of the show, the brooms were auctioned off to the audience, bringing in an additional $22.50 above ticket sales. The highest bid paid was $5, for Bessie Crowell's broom. The event raised a total of $63, which was deposited into the streetlight fund. Pictured, from left to right, are the following: (front row) Alice Crocker, Annabel Coleman, Isabella Wyer, Hattie Bacon, Lydia Lovell, and Bessie Crowell; (middle row) Mary Gibbs, Blanche Crowell, Nellie Coleman, Lizzie Gibbs, Hattie Fowler, and Etta Crowell; (back row) Carrie Ellis. (Courtesy of the Centerville Historical Museum.)

BENJAMIN D. BAXTER. In 1919, after the harbor was dredged, Benjamin D. Baxter (1879–1945), a customs agent on the railroad wharf and the son of Capt. Benjamin D. Baxter, had the foresight to buy waterfront property at the foot of Pleasant Street. (This is not Baxter's Wharf mentioned in histories of Hyannis; that wharf was farther east and was probably named for Alexander Baxter Jr.) Baxter was an entrepreneur who pursued a number of commercial ventures in his life, including pearl manufacturing. He is shown here with his wife, Elizabeth (right), and his daughter-in-law Elizabeth. (Courtesy of Samuel T. Baxter.)

WALTER CARNEY. Walter Carney's life was spent on the water and at its edge. In Hyannis Port in the late 19th century, he built fishing and pleasure boats and ferried customers around Lewis Bay and beyond. His most famous boat was the *Hattie B.*, a catboat. During a July 4, 1897 race off Hyannis Port, the *Hattie B.*, a favorite to place well, sprang a leak, requiring the crew to bail it out for the rest of the race. Despite the mishap, the boat came in third. (Courtesy of William L. Crocker.)

THE FATHER OF HYANNIS. He was a native of West Yarmouth and went to sea at age 12, penniless and uneducated. Yet Alexander Baxter Jr. (1796–1870) became known as the father of Hyannis after years of significant and lasting contributions to the village. He was just 16 during the War of 1812, when he sailed the New England coast, eluding British privateers aboard his fishing sloop *Polly*. He went on to become a successful coasting captain. He became a prominent Hyannis shipowner, businessman, and influential civic leader by the time he was in his mid-thirties. (From *Hyannis Sea Captains*, by C.E. Harris, 1939.)

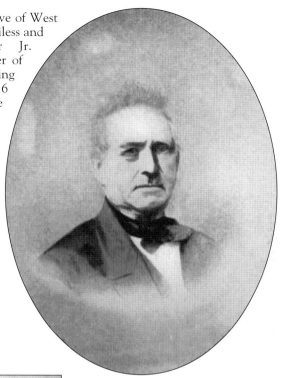

A PROMINENT LEADER. E.L. Chase was a respected businessman in the 19th and early 20th centuries. In the early 1870s, he joined his father and brothers in the family grain, coal, and hay business, H.B. Chase and Sons (across Main Street from the depot). He managed the business for more than 40 years. He was also a notary public, justice of the peace, and insurance agent and served in many volunteer capacities. He died on January 1, 1920. (Courtesy of the Barnstable Patriot.)

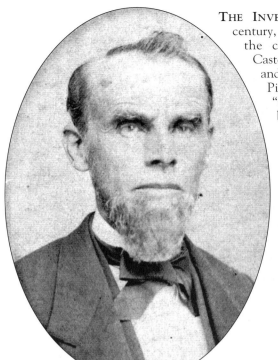

THE INVENTOR OF CASTORIA. In the mid-19th century, Hyannis doctor Samuel Pitcher invented the children's medicine he called Pitcher's Castoria. It was used to remedy stomach aches and constipation. His slogan, "Children Cry for Pitcher's Castoria," was better known as "Children Cry for Fletcher's Castoria" because in 1869 Pitcher sold the formula to New York businessman Charles Fletcher for $10,000. Pitcher's Way in Hyannis is said to have been named for the doctor's great-grandfather Joseph Pitcher. (Courtesy of the Hyannis Public Library.)

LOUIS ARENOVSKI. Lithuanian immigrant Louis Arenovski (1861–1937) was one of Hyannis's most respected businessmen in the late 19th and early 20th centuries. After running a thriving clothing store for many years, he went into the real estate field and was equally successful at that. Despite his stature in the community and his leadership role in the Republican party, he was friends with people from all stations in life and with different political views. He and his wife, Julia, had one son, Louis Arenovski Jr. (Courtesy of the Barnstable Historical Society.)

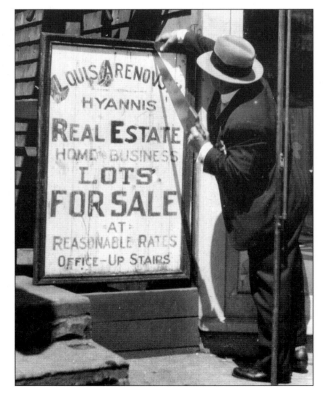

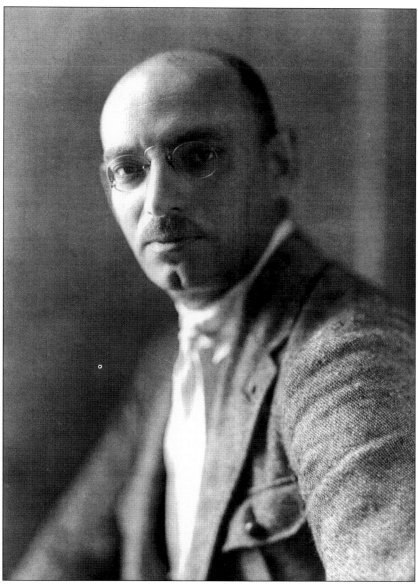

EDWARD I. PETOW. Edward I. Petow, a chemist, artist, musician, and entrepreneur, was a pioneer in the manufacture of artificial pearls in the United States. He developed a technique c. 1917 for making a lustrous milky coating for glass beads and eventually began making faux pearls in his factory in the former Hyannis Yacht Club building, which he had bought with Herman Finkelstein in 1919. Born in Odessa, Russia, in 1877, Petow studied art throughout Europe before moving to the United States with his wife, Henriette, and young son in 1906. Once on Cape Cod, he made the translucent coating he called Essense d'Orient from the scales of herring caught in local streams. He called his product Cape Cod Pearls and sold them through his business, Cape Cod United Products Company. In the mid-20th century, Petow's pearl business was forced to close, largely due to competition from overseas manufacturers. Petow spent the rest of his life on Cape Cod, where he was active in civic organizations. He died in Hyannis in 1958. (Courtesy of Joanne Murphy.)

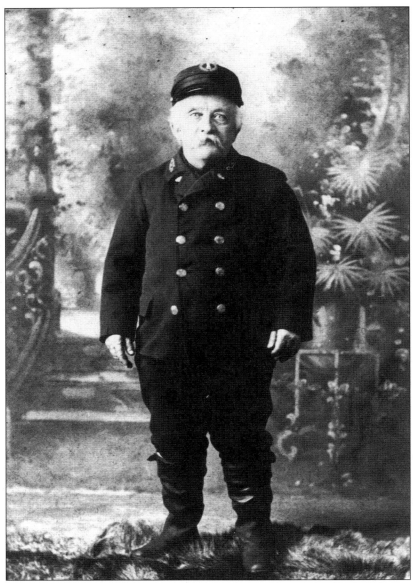

CHARLES H. HINCKLEY. Charles H. Hinckley (1849–1931) was the last lighthouse keeper at Bishop and Clerks, serving for 27 years. He stood under five feet tall and was known as the "shortest lighthouse keeper." A Barnstable native, Hinckley went to sea at 16 as a deck hand aboard Capt. Seth Taylor's ship the *Fortune* and sailed throughout the world. His first stint on a lighthouse was as assistant keeper at Bishop and Clerks, starting in 1881. He was then keeper at Dumpling Rock Lighthouse, near New Bedford, for several years. He returned to Lewis Bay as keeper of Bishop and Clerks in 1892. He once called Bishop and Clerks "one of the most important lights on Cape Cod." He kept a garden at the lighthouse and trapped lobsters, which he would serve to his visitors or bring home to his family. He reportedly retired from his post when he reached the age cap of 70. After he died, a local newspaper remarked, "His short stubby figure and cheery greeting will be greatly missed." He was married to Dorinda H. Bearse. They had four children. (Courtesy of William L. Crocker.)

A LONELY POST. When Charles H. Hinckley retired as the keeper of Bishop and Clerks, no one could be recruited to replace him because the job was such a lonely one. Hinckley's schedule each month was 20 days on the lighthouse and 10 days off. Several times, weather and ice in the harbor prevented him from leaving, once for 48 days. The lighthouse had a kitchen, cellar, and three bedrooms. (Courtesy of William L. Crocker.)

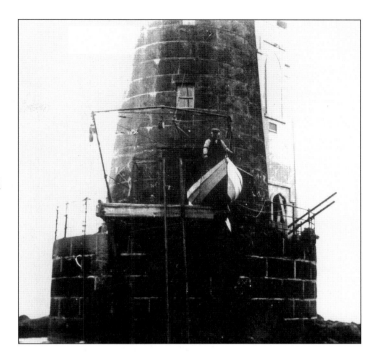

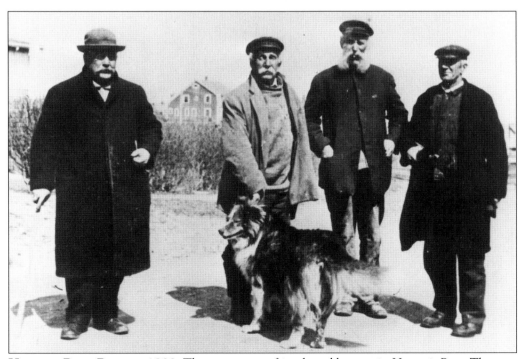

HYANNIS PORT PALS, C. 1900. These men were friends and boaters in Hyannis Port. They are identified as William Baker, Joe Phinney, Walter Carney, and Horace Cobb. (Courtesy of the Newman collection.)

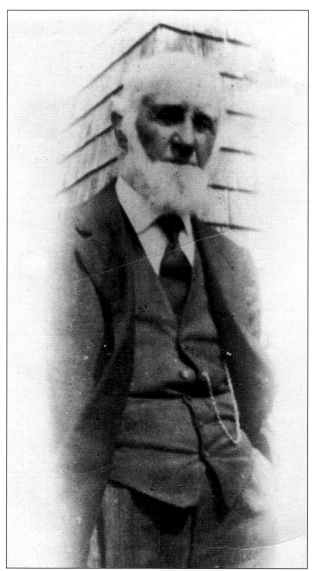

WENDELL L. HINCKLEY. In the late 1860s, former sea captain Wendell Lewis Hinckley (1832–1919) found a way to capitalize on the emerging phenomenon of tourism. He drove a horse-drawn barge, as primitive buses were called, shuttling Hyannis Port vacationers to and from the railroad depot each day in the summer. The fare one way was 25¢. His barge was also pressed into service on summer Sundays to ferry Episcopalians from Hyannis Port to the Universalist church in Hyannis, where they worshiped before their own St. Andrew's church was built. Hinckley was just eight when he went to sea, and his career on the water spanned 25 years. Among other ships, he commanded the schooners *Highlander*, *Daniel Webster*, and *Albany*, which was built in Osterville. Later, he captained yachts, including the *Idler*, which at the time was said to be the fastest yacht afloat. After retiring from the sea, Hinckley ran a grocery store in Hyannis briefly and was Hyannis Port's postmaster from 1873 to 1890. He was, according to columnist Clara Jane Hallett, "a warm-hearted kindly man, full of quaint humor, but also quick tempered and obstinate." (Courtesy of the Newman collection.)

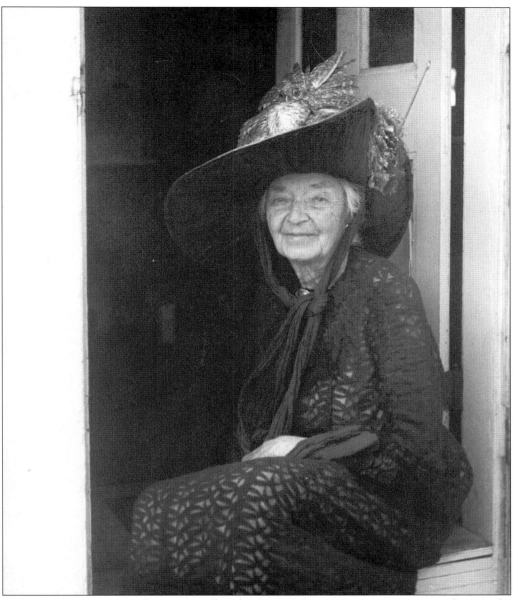

CLARA JANE HALLETT. Clara Jane Hallett (1858–1959) was a *Patriot* newspaper columnist for more than 40 years, writing about the town's history and offering sometimes critical opinions on current issues up until her death at age 100. She was the daughter of Emeline Hallett and sailmaker Josiah H. Hallett. She spent her life in the Ocean Street house that her grandfather Edmund Hallett built in 1831 and in which she was born. She helped her father stitch sails in his Pleasant Street sail loft and was a vocal advocate for a number of causes, including women's suffrage and women's rights. She went to high school in the School Street schoolhouse and was one of seven in her graduating class. At the time, the town claimed that it could not afford diplomas, and so she did not get one. Many years later, town officials presented her with a high school diploma. "It is needless to say I am a genuine Cape Codder," she once wrote in a column. "I believe in Cape Cod. I love it." (Courtesy of the Centerville Historical Museum.)

JOHN BODFISH, THE BLIND LAWYER. John Dunning Whitney Bodfish (1878–1956), a well-known Hyannis lawyer, was 22 and a teacher when he became blind. He refused to let his disability hinder his professional or personal success. He attended the Perkins School for the Blind in Watertown and, at age 32, went to Boston University's law school, graduating in 1913. He returned to Hyannis, where he started a law practice and became a Barnstable County commissioner. He was active in efforts to preserve Sandy Neck Beach, to establish Cape Cod Hospital, to build the mid-Cape highway, and to construct the Bourne and Sagamore Bridges. He was a passionate and persuasive speaker at town meetings and spoke of the need to control development and protect the environment. In 1926, he became the first Cape Cod lawyer to be admitted to practice before the U.S. Supreme Court. Bodfish grew up in Hyannis. He graduated from high school at the School Street schoolhouse and, in 1899, from the State Normal School at Hyannis. He became a teacher and school principal in Osterville before losing his sight. (Courtesy of the Barnstable Patriot.)

ORA ADAMS HINCKLEY. Ora Adams Hinckley (1857–1943) was a beloved Hyannis resident and the public library's first full-time librarian, overseeing the library from 1909 until her death. She was also an expert on Cape Cod history, an author, and active in town affairs. She was a direct descendant of Pres. John Adams. In 1886, she married S. Alexander Hinckley, who worked for the postal service. She became a loving stepmother to his three children, and they had one daughter of their own. In 1943, the original library building was named for her. (Courtesy of the Hyannis Public Library.)

BASIL AND ALVAH BEARSE. In 1976, Alvah W. Bearse (right) wrote the book *Physic Point*, a collection of memories of his childhood in Hyannis. In 1981, after a career as an executive and college professor in Michigan, he returned to Hyannis, to the home his grandfather built on Ocean Street. He is shown in this c. 1920 photograph with his brother Basil, who became a landscape designer. Another brother, Thurlow, succeeded their father as owner of Bradford's Hardware. (Courtesy of Alvah W. Bearse.)

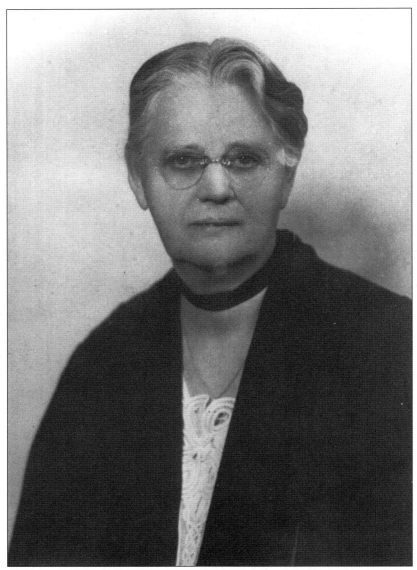

SARAH A. DIXON. Rev. Sarah A. Dixon became pastor of the fledgling Federated Congregation (later the Federated Church), a union of the Universalist and Congregational Churches, in 1917. Although the merger had begun prior to Dixon's tenure, she was largely responsible for shepherding the union and ensuring its success. Dixon was an enthusiastic, popular, and progressive preacher. Although she was in Hyannis for only seven years, her contributions were far-reaching and lasting. She was a world traveler, a businesswoman, a poet and writer, and an expert on the poetry of Robert Browning. *My Cape Cod* is a published collection of her own poems. She left Hyannis in 1924 to serve the Amicable Congregational Church in Tiverton, Rhode Island. In Hyannis and Rhode Island, she was credited with proving to many that a woman could be a successful pastor. She was born in Barnstable, went to local schools, graduated from Bridgewater State Teachers College, and received a doctor of philosophy degree from Boston University. She never married. She died at age 74 in Rhode Island in 1939. (Courtesy of the Federated Church.)

NATHAN OSCAR BOND. Virginia native and tinsmith Nathan Oscar Bond (1836–1914) sold his Main Street hardware business to Alexander G. Cash in 1866. He married Alice Binder Simmons, the daughter of sea captain Lemuel B. Simmons, in 1868 at the Universalist church in Hyannis. The couple returned to his family's plantation in Virginia, where they raised their children. When he died, Alice returned to Hyannis, where her children were already making names for themselves. (Courtesy of Ed and Sandy Bond.)

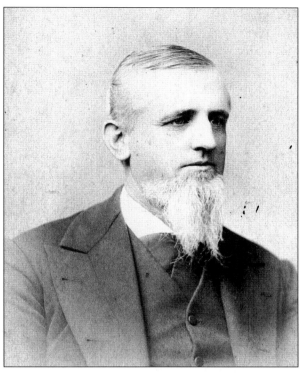

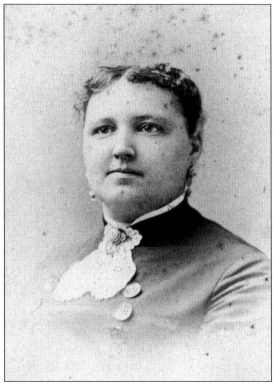

ALICE BINDER SIMMONS BOND. Alice Binder Simmons (1850–1923) was the only child of Capt. Lemuel B. Simmons and second wife Eliza. She married Nathan Oscar Bond in Hyannis in 1868, and they moved to Virginia, where they raised five children, including Horatio Simmons Bond and Everett Oscar Bond, both fixtures in Hyannis in the early 20th century. Alice returned to Hyannis shortly after her husband's 1914 death and lived on Ocean Street until her death. (Courtesy of Ed and Sandy Bond.)

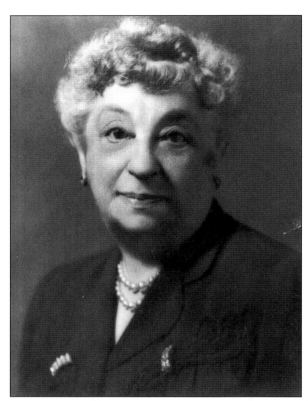

SHE BUILT A CANDLE EMPIRE.
Mabel Kimball, founder of the
Colonial Candle Company of Cape
Cod, was a Danvers native who
came to Hyannis to teach home
economics at the State Normal
School at Hyannis. She married
department store owner Walter D.
Baker in 1907. In addition to being
a candle mogul, Baker was active in
the Cape Cod Chamber of
Commerce, the Massachusetts
Society for the Prevention of
Cruelty to Children, Cape Cod
Hospital, and the Federated Church.
(Courtesy of the Barnstable Patriot.)

W. LEO SHIELDS. W. Leo Shields was a sports hero
at Barnstable High School in the 1930s, running
track and playing football, basketball, and baseball.
He went on to play football at Holy Cross and was
elected to the college's hall of fame. In 1938, he was
hired as a history teacher and line coach at
Barnstable High School and went on to serve as
football coach, athletic director, and assistant
principal. He died suddenly in the summer of 1962.
On Thanksgiving Day that year, the new football
field at the high school was dedicated to him.
(Courtesy of Sean Walsh.)

Five

THE RAILROAD

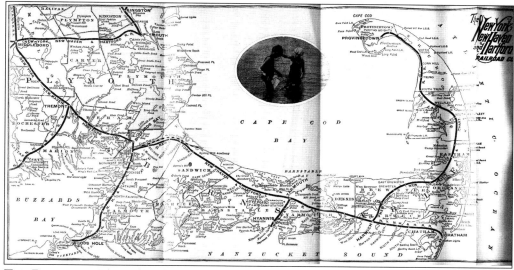

THE RAILROAD. The railroad came to Cape Cod in 1848 with the opening of a 27-mile line from Middleboro to Sandwich. It reached Hyannis in 1854, boosting commercial activity in town. The railroad "changed our village from a hamlet into a growing prosperous community," wrote columnist Clara Jane Hallett in 1942. Nantucket residents were among the most vocal proponents of the plan to bring the railroad to Hyannis. After all, Cape Cod was the island's first stop on the mainland, and therefore a reliable modern transportation infrastructure was critical to the economy of the island. Hyannis, about 30 miles across Nantucket Sound, was closer than New Bedford, which had been the island's chief mainland port. As soon as the spur from the Main Street depot to the shore was complete (along what later became Old Colony Boulevard), the Nantucket Steamboat Company discontinued the Nantucket–New Bedford route and began docking in Hyannis instead. The island abandoned Hyannis in 1872, when the railroad reached Woods Hole. Although that port was not closer, it allowed the steamers to pick up business from Martha's Vineyard on the way. This map is dated 1927.

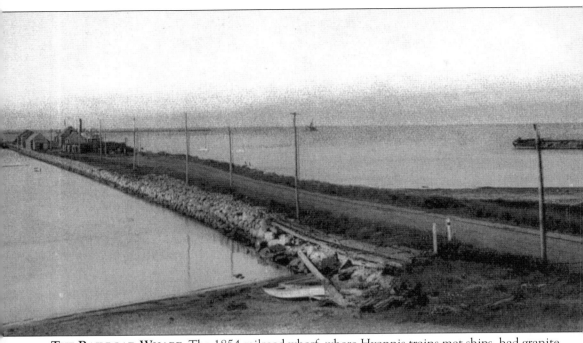

THE RAILROAD WHARF. The 1854 railroad wharf, where Hyannis trains met ships, had granite walls and was 1,000 feet long and 200 feet wide. At the end was an L-shaped wooden wharf where boats tied up. For many years, it was the center of commercial boating activity in Hyannis. Heman Chase and David Marchant were among the first to establish a business there when they opened their ship chandlery in 1856 and continued to run a packet line Chase had begun earlier. There was also a busy lumberyard and numerous other businesses. In 1872, when the boat line shifted the mainland terminus from the railroad wharf to Woods Hole, Hyannis townspeople lamented the loss of the island business. In July 1872, the *Patriot* newspaper reported, "The Nantucket travel, in one way or another, has brought considerable money into the place, and our carriage drivers, as well as hotel and saloon keepers will very much miss the income from this source." Still, plenty of other ships docked at the wharf, keeping it bustling. When the wharf was abandoned in the early 20th century, some of the granite blocks were used to complete the Hyannis Port breakwater, which had been started in 1826. The wharf and some land were sold by the railroad in 1938 to David McCargo for $7,500. (Courtesy of the Centerville Historical Museum.)

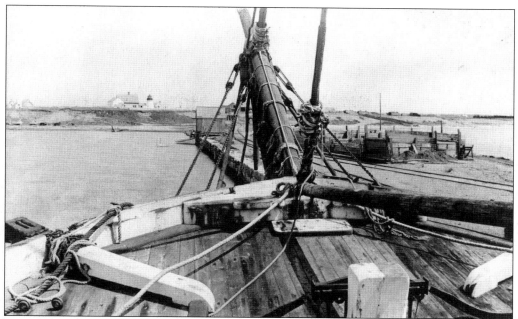

ON THE BOW OF THE SCHOONER *FRANKLIN*. From the bow of the schooner *Franklin,* tied up at the railroad wharf in the 1890s, South Hyannis Light can be seen on the south bluff in the distance. This photograph was reportedly taken in 1898. As an illustration of the volume of commerce done at the wharf in the late 19th century, in 1893 about 14,750 tons of coal and 53,348 bushels of grain were offloaded there to H.B. Chase and Sons and 3,000 barrels of fresh fish were unloaded and shipped by rail to markets from Boston to New York. (Courtesy of the Hyannis Public Library.)

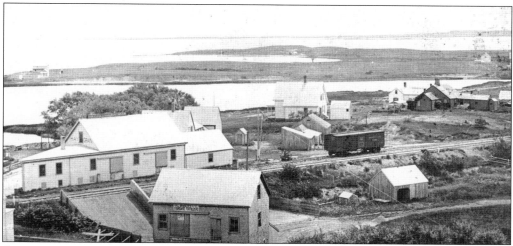

OVER THE OLD COLONY ROUTE. This aerial view shows the old railroad tracks running toward the railroad wharf. In 1937, the New York, New Haven and Hartford Railroad received permission from the federal government to abandon the line from the Hyannis center to the wharf. The news, however, was of little consequence, as the line had not been used in many years. The tracks were eventually removed, and Old Colony Boulevard was built in their place. (Courtesy of the Hyannis Public Library.)

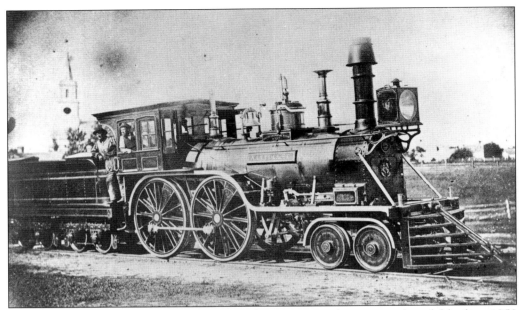

THE LOCOMOTIVE NANTUCKET. The *Nantucket* was an inside-connected model built *c.* 1858 by Hinkley and Drury's Boston Locomotive Works. It was the fifth locomotive of that design to be purchased from Hinkley and Drury by the Cape Cod Railroad. The name was apt, since the railroad's arrival in 1854 made Hyannis the island's first stop on the mainland for most goods and passengers traveling from Nantucket to Boston and throughout New England. (Courtesy of Philip H. Choate.)

PAYMENT FOR SHOVELING COAL. This October 8, 1875 receipt from the Old Colony Railroad shows payment of $6 for three days of "shoveling coal into shed from two cargoes." (Courtesy of Philip H. Choate.)

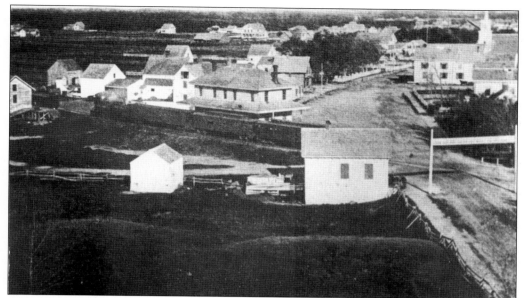

A BIRD'S-EYE VIEW OF THE DEPOT. This *c.* 1858 photograph shows the railroad depot in the center. The sign high over Main Street is a railroad crossing warning. When the railroad came to town in 1854, it soon put the stagecoaches and, eventually, the sailing packets out of business. The packets were once the chief means of communication with Boston and the rest of the world. They carried mail, goods, and passengers. (Courtesy of Philip H. Choate.)

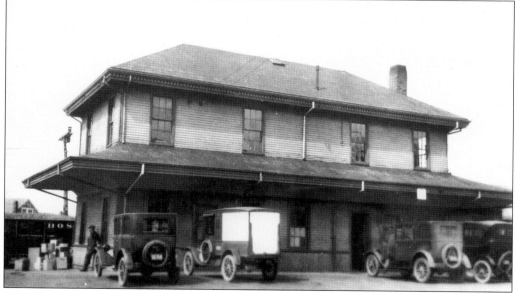

THE DEPOT, C. 1925. On July 8, 1854, the railroad reached Hyannis, strengthening the village's reputation as the hub of Cape Cod. When the first train, flags flying, steamed into the village that day and pulled up next to the crisp new depot on Main Street, it was met by a crowd of more than 3,000 ebullient townspeople and celebratory cannon fire. That night, the festivities continued with a clambake. The first schedule for Hyannis had three trains to and from Boston daily. (Courtesy of Philip H. Choate.)

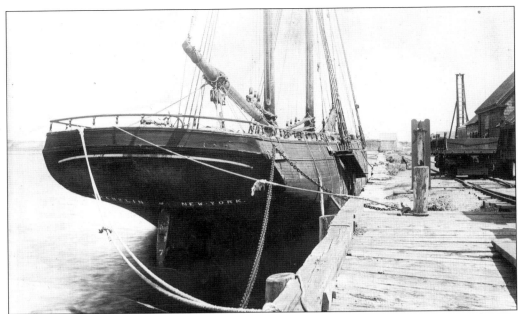

THE SCHOONER FRANKLIN AT THE RAILROAD WHARF. The *Franklin* was one of many schooners that stopped at the railroad wharf during its heyday in the mid-to-late 19th century. By the early 20th century, need for the wharf was declining. One atypical business in the later years was a nightclub that opened in 1929 in a renovated barkentine, the *Fairhaven*. It was burned down by vandals. The wharf was sold in 1938. (Courtesy of the Newman collection.)

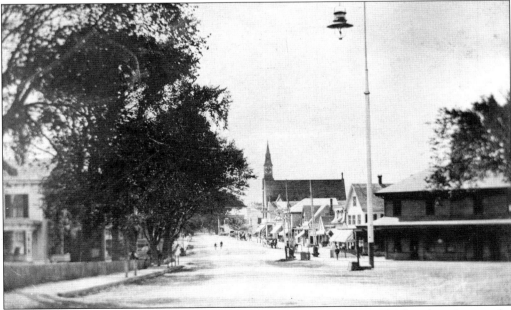

DEPOT SQUARE. This photograph shows Depot Square before the 1904 fire that destroyed a block of Main Street (shown between the depot and the church). The square was "the center of village activities longer than any other one portion of Hyannis," wrote columnist Clara Jane Hallett in the *Patriot* in 1942. (Courtesy of the Barnstable Patriot.)

A VISIT FROM THE LEGISLATURE. During the 1890s, Barnstable and other towns explored the possibility of installing electric street railroads. Had the railroads happened, the first route would likely have been a line linking Woods Hole and Hyannis. So serious were proponents that the Barnstable County Electric Railroad got a charter in 1896. Backers included cranberry king Abel D. Makepeace (president of the First National Bank of Hyannis), George F. Baker, J. Malcolm Forbes, and Russell Marston. In April 1896, a state legislative committee on street railways (shown here) came to Cape Cod to have a look at the proposed route. The lawmakers stayed at the Iyanough House (left) and were entertained by local businessmen at the Saturday Night Club. The *Patriot* newspaper reported, "The reception was informal throughout. Our people paid their respects to the visitors, and all mingled and smoked and talked over the proposed electric road with one another." The visitors seemed "favorably disposed towards the enterprise," the paper stated. Despite efforts, the plan never materialized. (Courtesy of the Hyannis Public Library.)

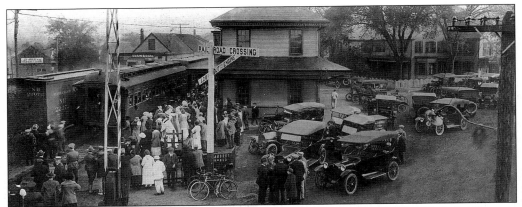

SAYING GOODBYE AT THE DEPOT. When Cape Cod enlistees in World War I left the Hyannis depot on a September morning in 1917, they were given a warm and hearty send-off. Well-wishers included normal-school faculty members and students, who marched to the station and waved American flags. Before boarding the train, the men stood for a roll call. A crowd sang patriotic songs as the train pulled out of the station. (Courtesy of the Centerville Historical Museum.)

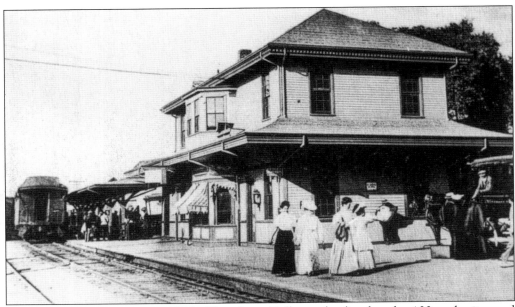

THE RAILROAD DEPOT, C. 1909. Clara Jane Hallett, who lived to be 100 and witnessed enormous change in her village, once wrote, "The old depot has withstood the hand of time. It is the only thing that looks the same when people come home after a long absence." The station originally had two waiting rooms—one for men and one for women. Later, there was just one big room. (Courtesy of Philip H. Choate.)

Six
THE KENNEDYS IN HYANNIS PORT

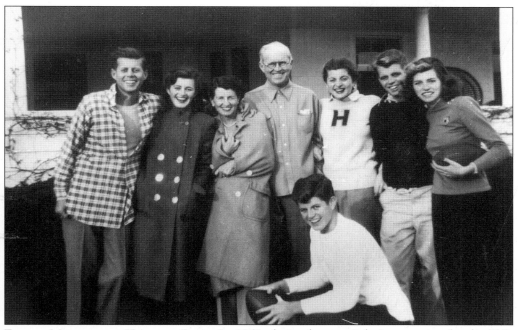

FAMILY MEMBERS IN HYANNIS PORT. In 1952, during her son John's campaign for the U.S. Senate, Rose Kennedy told an audience at Barnstable's town hall, "Our family would rather be in Hyannis Port in the summer than any place else in the world." This photograph was taken in Hyannis Port during the Thanksgiving holiday in 1948. John F. Kennedy, looking boyish at 31, had been elected to Congress two years earlier. The Kennedys had been summering on Cape Cod for more than two decades by 1948. They started renting the former "Malcolm cottage" at the end of Marchant Avenue c. 1925 and bought the turn-of-the-century waterfront house in 1928. By the time this photograph was taken, tragedy had already begun to strike the family. Sister Kathleen Kennedy Cavendish had been killed in a plane crash in France earlier that year; eldest brother Joseph Jr. had been killed in 1944 in World War II; and sister Rosemary, born with a developmental disability, had been institutionalized in 1941. In this photograph, Edward (Ted) Kennedy is kneeling in front. The others are, from left to right, John, Jean, Rose, Joseph, Patricia, Robert, and Eunice Kennedy. (Courtesy of the John Fitzgerald Kennedy Library.)

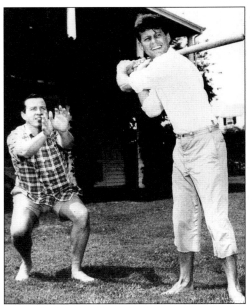

BATTING PRACTICE. In Hyannis Port with future brother-in-law Sargent Shriver (left) in 1952, John F. Kennedy keeps his eye on the ball. For the future president, Cape Cod was an oasis, a refuge where he said he could best relax and think. He once said that walking the beaches of the Cape would always help him make an important decision. (Courtesy of the Cape Cod Times.)

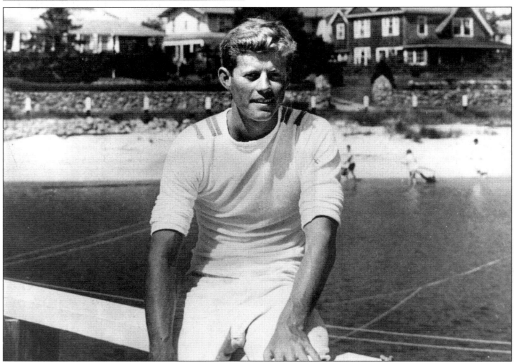

RELAXING BY THE WATER. During his campaign for the U.S. House of Representatives in 1946, John F. Kennedy takes a break at the Hyannis Port Yacht Club's pier. Kennedy was running for the seat vacated by former Boston mayor James Michael Curley and once held by his grandfather, John F. "Honey Fitz" Fitzgerald. In November, he defeated his opponent, Republican Lester W. Bowen, by a margin of more than two to one. It was his first election to public office. (Courtesy of the John Fitzgerald Kennedy Library.)

FAMILY AND FRIENDS ON THE PORCH. In the summer of 1944, some of John F. Kennedy's crew mates who served with him aboard the PT-109 in World War II visited Hyannis Port. This 1944 photograph at the family home shows Kennedy siblings, the future president, and his buddies and neighbors. (Courtesy of the John Fitzgerald Kennedy Library.)

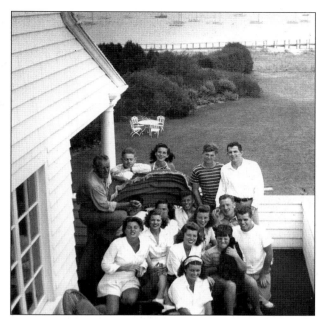

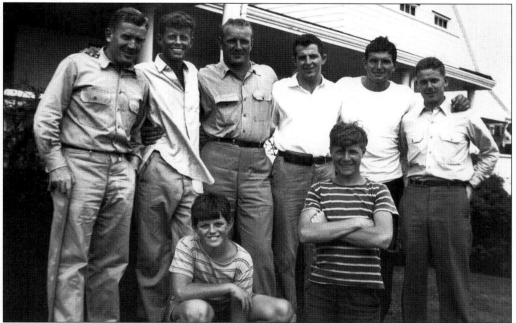

KENNEDY WITH HIS PT-109 CREW. John F. Kennedy's service in World War II will probably be best remembered for his heroic role in the rescue of most of his crew when the boat he skippered, PT-109, was rammed and split in two by a Japanese destroyer in August 1943 off the Solomon Islands. Two members of the PT-109 crew were killed. Kennedy was recognized for his heroism and went on to command PT-59. Pictured in Hyannis Port in 1944 are, from left to right, the following: (front row) Edward M. Kennedy and cousin Joseph Gargan; (back row) Paul "Red" Fay, John F. Kennedy, Leonard Jay Thom, Jim Reed, Barney Ross, and Bernie Lyons. (Courtesy of the John Fitzgerald Kennedy Library.)

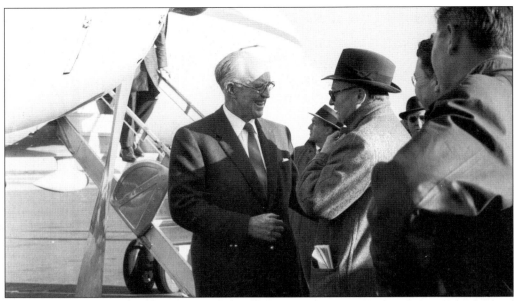

JOSEPH P. KENNEDY MEETS THE PRESS. First father Joseph P. Kennedy, ambassador and patriarch, was as ambitious for his sons as he was for himself. He groomed his sons for high political office and his daughters for the upper echelons of society in which they would travel. He was born in Boston in 1888, the son of a saloon keeper, and went on to build a fortune in banking, shipbuilding, and movie distribution. He and Rose Fitzgerald, the daughter of Boston's mayor, married in 1914 and raised nine children. He died in Hyannis Port in 1969. (Courtesy of Gordon E. Caldwell.)

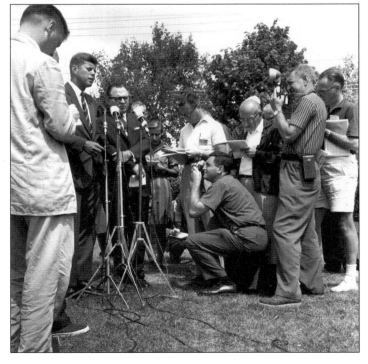

A CAPE COD PRESS CONFERENCE. John F. Kennedy seemed at ease in front of the cameras and cultivated a friendly rapport with the media. His dramatic capture of the Democratic nomination for president in the summer of 1960 put Hyannis Port on the map. The attention, however, was not welcomed by some. The invasion of tourists and reporters prompted irate locals to petition selectmen to barricade entrances to the neighborhood, allowing in only residents and guests. The petition was quickly rejected. (Courtesy of Gordon E. Caldwell.)

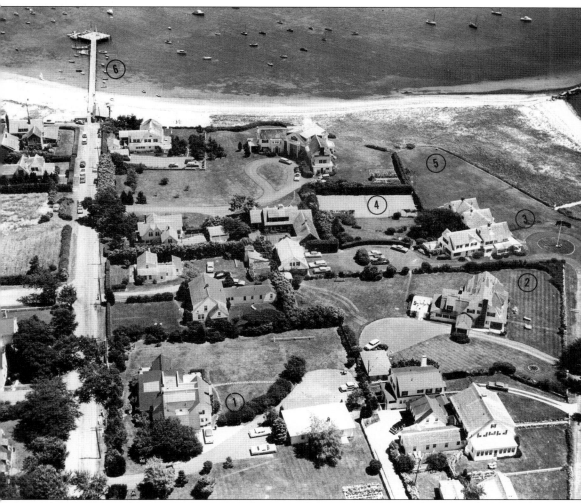

AN AERIAL VIEW OF THE COMPOUND. The Kennedy compound overlooks Nantucket Sound and includes the Marchant Avenue home (3) that Joseph and Rose Kennedy bought in 1928; the home next door (2), owned by Robert F. Kennedy and his wife, Ethel; and the home on Irving Avenue (1), purchased by the future president on October 9, 1956, for $45,948. That home is now owned by Caroline Kennedy Schlossberg. Many other houses in the neighborhood have been purchased by Kennedy family members over the years. Hyannis Port was a coveted address long before the Kennedys arrived. When the Democratic Irish Catholic family moved to the area, they got a lukewarm reception from the largely Republican blue bloods who summered there. It was more than just political or religious differences that caused locals to slight them. The Kennedys' own independence and competitive nature did not endear them to their neighbors. There were many, however, who were delighted to call the Kennedys neighbors. (Courtesy of the Cape Cod Times.)

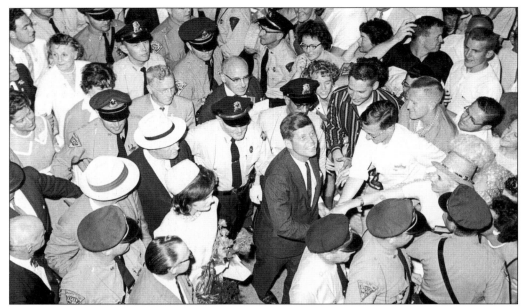

THE FUTURE PRESIDENT ARRIVES IN HYANNIS. When John F. Kennedy arrived at the municipal airport in Hyannis on July 17, 1960, after winning the Democratic presidential nomination in Los Angeles, he was greeted by a swarm of photographers and reporters and a crowd of fans. At the airport, he said, "I've never made a political speech in Hyannis in thirty years and I don't intend to make one now." He was slightly mistaken. He had made a speech in October 1958 at the National Guard Armory while running for the Senate. (Courtesy of the Barnstable Patriot.)

THE CAROLINE. The *Caroline* was John F. Kennedy's campaign plane, purchased for him by his father in 1959 from American Airlines, which had used it as a commercial carrier. In 1967, the plane was donated to the National Air and Space Museum by the Kennedy family. (Courtesy of Gordon Caldwell.)

THE 1960 ANNUAL REPORTS. Hyannis, a village in the town of Barnstable, was thrust into the limelight in 1960 when John F. Kennedy was elected president of the United States. This is the cover of the 1960 Barnstable annual reports, indicating how proud the town was of its most famous summer resident. Kennedy delivered his acceptance speech in Hyannis after winning the election. (Courtesy of the Barnstable Patriot.)

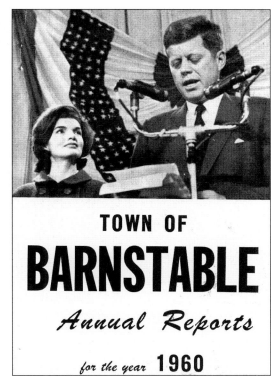

TOWN OF

BARNSTABLE

Annual Reports

for the year **1960**

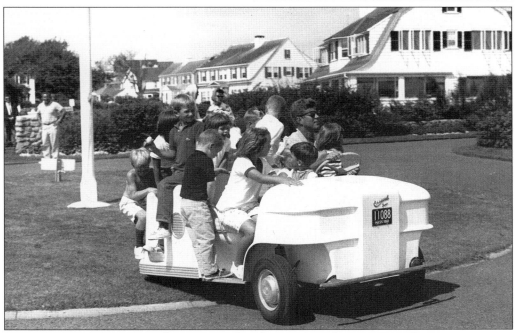

THE PIED PIPER. In 1962, John F. Kennedy takes time out from running the country to give Caroline and his nieces and nephews a ride around the compound property in a golf cart. (Courtesy of the John Fitzgerald Kennedy Library.)

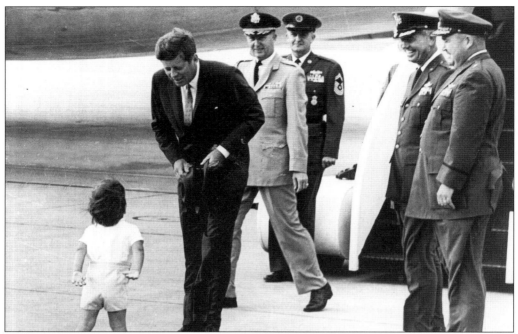

GREETING HIS FATHER AT OTIS AIR FORCE BASE. In 1963, toddler John Jr. greets his father as the president arrives at Otis Air Force Base on the upper Cape. The president typically landed at Otis when he arrived on Cape Cod. Third child Patrick Bouvier Kennedy was born at the base hospital in 1963 but sadly lived just two days, dying at Children's Hospital in Boston. (Courtesy of the Cape Cod Times.)

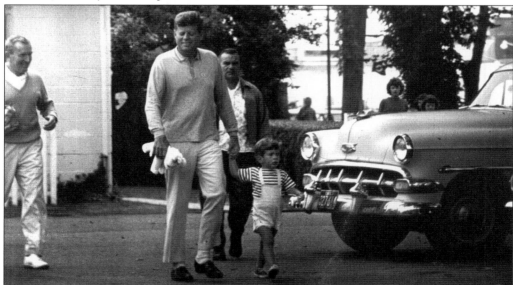

A VISIT TO THE VILLAGE WITH DAD. On a summer day in 1963, John F. Kennedy takes a walk with his son John Jr. to the candy store. "Downtown Hyannis Port," less than half a mile from the president's home, included little more than a small post office and a seasonal variety store that sold newspapers, candy, ice cream, and paperbacks. (Courtesy of the John Fitzgerald Kennedy Library.)

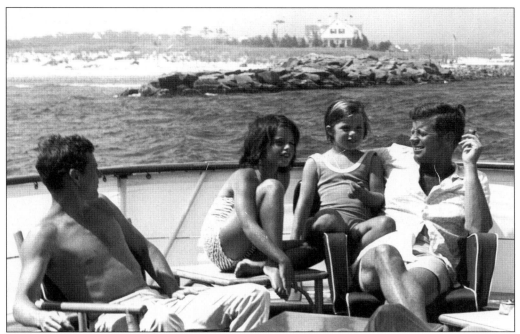

A DAY OF BOATING. With Hyannis Port in the background, John F. Kennedy (right) relaxes aboard the *Honey Fitz* in Hyannis Port Harbor in July 1963. The others are, from left to right, Kennedy's brother-in-law Stephen Smith (husband of Kennedy's sister Jean), niece Maria Shriver, and daughter Caroline. (Courtesy of the John Fitzgerald Kennedy Library.)

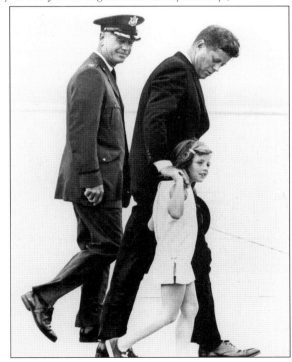

WALKING WITH CAROLINE AT OTIS AIR FORCE BASE, 1963. President Kennedy was often greeted by his children after landing at Otis Air Force Base. Kennedy flew out of the base for the last time in October 1963. (Courtesy of the Cape Cod Times.)

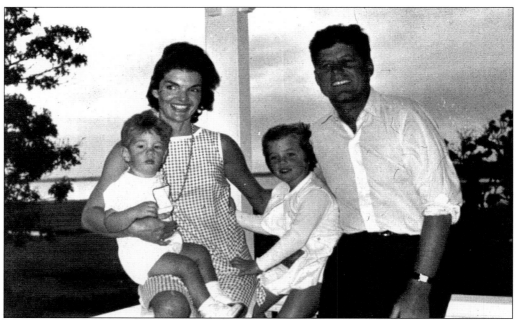

THE KENNEDY FAMILY. This portrait of the president and his family was taken in 1962 on Squaw Island, near Hyannis Port. For better security, the family moved from its Irving Avenue home to temporary quarters on the more secluded island, connected by a thin causeway to the mainland, during Kennedy's presidency. In 1960, Hyannis Port became a tourist destination internationally synonymous with the Kennedy name. (Courtesy of the John Fitzgerald Kennedy Library.)

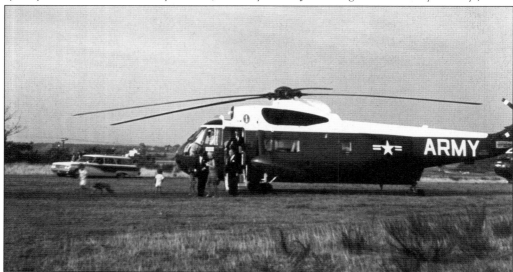

A WEEKEND VISIT. John F. Kennedy and his family routinely visited Hyannis Port on summer weekends. While he was president, the family lived on Squaw Island, which is connected to Hyannis Port by a causeway, rather than in their Irving Avenue home. The president would typically fly to Otis Air Force Base and then take an army helicopter to Hyannis Port. It landed on a makeshift landing pad on the island, near the home of brother Edward M. Kennedy and his then wife, Joan. (Courtesy of Glenn Clough.)

A Bathing Beauty. As a child, Caroline Kennedy, sometimes called "America's Princess," spent seemingly endless summer days swimming and boating off Hyannis Port with her relatives and friends. She was married to Edwin Schlossberg in 1986 at Our Lady of Victory Church in Centerville, and the reception was held at the Kennedy compound. (Courtesy of the John Fitzgerald Kennedy Library.)

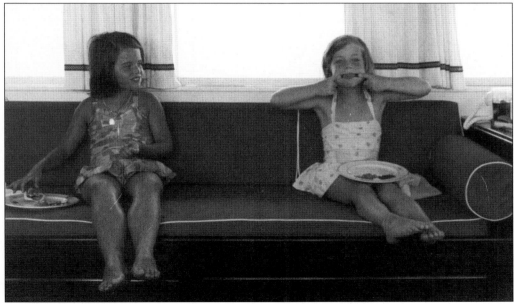

Maria Shriver and Caroline Kennedy on the *Honey Fitz*. Aboard the presidential yacht *Honey Fitz*, cousins Maria Shriver (left) and Caroline Kennedy seem to be enjoying a playful summer day in 1963. The boat's name honored the president's maternal grandfather, former mayor of Boston and member of the U.S. House of Representatives John Francis Fitzgerald. When Maria married Arnold Schwarzenegger in Hyannis on April 26, 1986, Caroline was her maid of honor. Maria returned the favor three months later when Caroline married Edwin Schlossberg on July 19. (Courtesy of the John Fitzgerald Kennedy Library.)

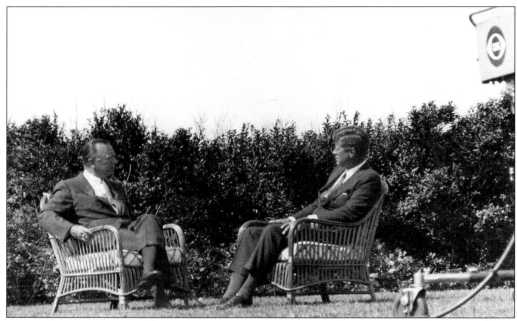

AN INTERVIEW WITH CBS. On September 2, 1963, CBS Evening News anchor Walter Cronkite interviews John F. Kennedy on Cape Cod. The network debuted its first half-hour news broadcast that night (they had always been 15 minutes), and the interview was the highlight. (Courtesy of the John Fitzgerald Kennedy Library.)

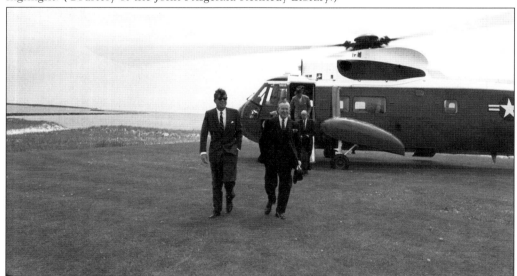

A VISITOR FROM CANADA. In May 1963, Kennedy (left) arrives on Cape Cod with Canadian prime minister Lester Pearson. One of Pearson's goals after becoming prime minister was to mend Canadian-American relations, which had deteriorated under former prime minister John Diefenbaker's leadership. Pearson was successful, and he and Kennedy established an easy friendship. The healthy rapport with the United States did not, however, survive for long after Kennedy's death, particularly as the United States became entrenched in the Vietnam War. (Courtesy of the John Fitzgerald Kennedy Library.)

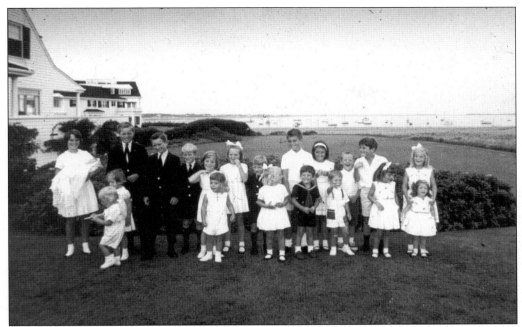

KENNEDY COUSINS READY FOR A FAMILY PORTRAIT. In their best outfits, young Kennedy cousins are lined up on the family's lawn in Hyannis Port to have their picture taken in 1963 with their grandmother, Rose Fitzgerald Kennedy (not shown). (Courtesy of the John Fitzgerald Kennedy Library.)

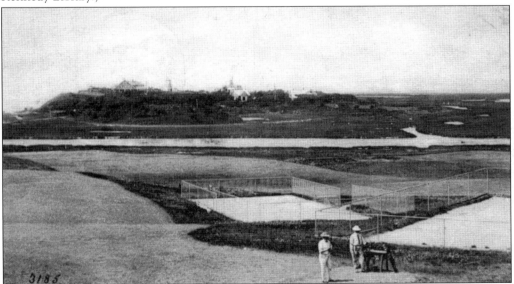

SQUAW ISLAND. When he was president, John F. Kennedy and his family lived on Squaw Island, as it was deemed more secure than his Irving Avenue property, located in the heart of Hyannis Port. In 1872, the town of Barnstable sold all of Squaw Island to a syndicate of developers for $200 even though it had been set aside in the early 19th century for the town's school system. The island is seen in this photograph from the Hyannisport Club. (Courtesy of the Newman collection.)

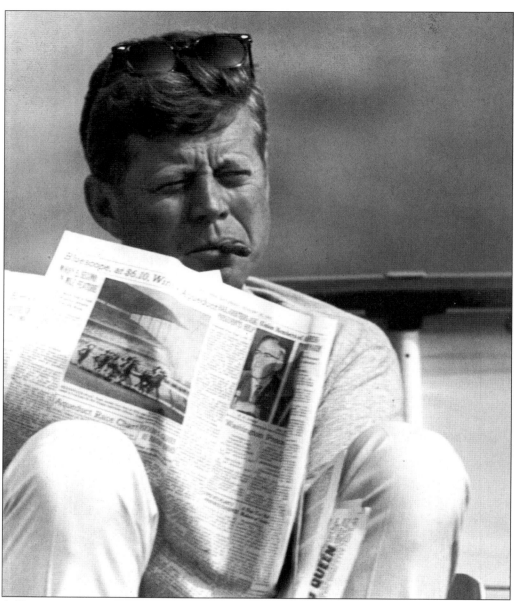

A PORTRAIT OF THE PRESIDENT. John F. Kennedy loved Hyannis Port and spent countless hours on the water. He learned to sail with his siblings as a child and was quickly winning local races and collecting a shelf full of trophies. One of the first Kennedy sailboats was purchased in 1927 and named by John and Joe Jr. the *Rose Elizabeth* for their mother. They also sailed the Wianno Jr. *Tenovus* for many years. Kennedy, however, is better known for skippering the handsome 26-foot wooden Wianno Sr. *Victura*, which was built by Crosby Yacht Yard in Osterville in 1932. His parents gave it to him on his 15th birthday, and he sailed it for the rest of his life. He is shown here in August 1963 relaxing aboard the presidential yacht *Honey Fitz*, named for his maternal grandfather. He seems carefree and content reading the newspaper and puffing on a cigar. Sadly, it was just months before his assassination in Dallas. (Courtesy of the John Fitzgerald Kennedy Library.)

Seven
HISTORIC HOMES

THE OCTAGON HOUSE. Capt. Rodney Baxter (1815–1888) built this concrete mauve three-story house and barn on South Street in 1855. Baxter was a colorful deepwater and coasting captain who commanded, among other vessels, the *American Belle* and the *Flying Scud* and set several records for speed. In 1855, for example, he took the clipper ship *Flying Scud* from New York to Marseilles in a record 19 days. He set another record a year later when he took *Flying Scud* from New York to Bombay in 81 days, a passage even more impressive because his crew twice mutinied. In 1847, he was one of several local captains who loaded their ships with corn, grain, flour, and other staples and brought the provisions to Ireland during the great potato famine. In the late 1850s, Baxter was in command of steamers running packets between New York and New Orleans. In June 1855, when the home was being built, the *Patriot* reported, "We are inclined to believe from an examination of the structure, that when built correctly, these houses will stand longer than any wooden house ever built. But we may be mistaken." At the start of the 21st century, the home was still in Baxter's family, owned by his great-granddaughter. (Courtesy of the Barnstable Patriot.)

THE ORMSBY HOUSE. This home on Main Street was once owned by Capt. Alvin S. Hallett (1808–1887), whose vessels included the *Phantom* and the *Northern Crown*. William F. Ormsby, who worked for the railroad in Hyannis, bought the home in 1888 from Hallett's son Alvin for $2,300. It stayed in the Ormsby family until 1955. It was torn down in the late 1950s, and a bowling alley was built on the site. (Courtesy of Ellen Sullivan Rivers.)

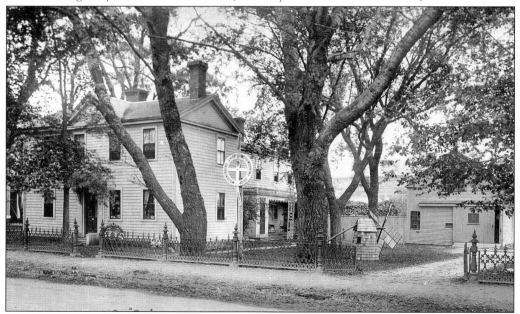

SMITH'S WOODWORKING SHOP. In the early 20th century, this Main Street home was owned by carpenter J. Arthur Smith, who had his woodworking shop attached to the house. He sold it in 1925 to developer F.W. Norris of Boston and Florida, and he and his wife, Mary Ellen Ormsby, moved to North Street. The couple had one son, William. (Courtesy of Elsie Hudson.)

THE OLDEST HOUSE IN HYANNIS. This home—originally located on Lewis Bay on the eastern edge of town—was built *c.* 1690 by Edward Coleman Jr. It is believed to be the first house built in Hyannis. The mortar was made of oyster shells, and it had walls of horsehair plaster. It was given to the Barnstable Housing Authority by Hyannis Marina owner Wayne Kurker in 1999 and was moved to Pleasant Street, where it was renovated to be used for rental housing.

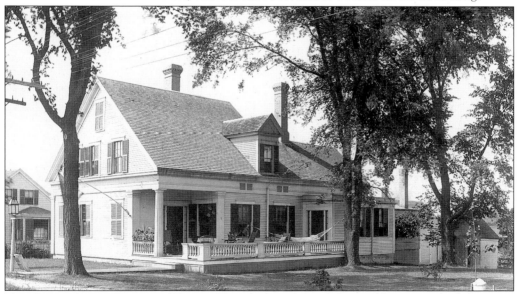

THE CAPT. ALLEN CROWELL HOUSE. This clapboard Greek Revival home was built by Capt. Allen Crowell (1821–1891) on Pleasant Street in 1852. Crowell began his career at sea as a cook aboard a coasting vessel at age 10. By age 21, he was the captain of a clipper ship and traveled the world, trading. Like captains Rodney Baxter and Jehial Simmons, Crowell brought food to Ireland in 1847 during the great potato famine there. He married Phoebe Miner, a Connecticut schoolteacher. They had five children. (Courtesy of the Barnstable Patriot.)

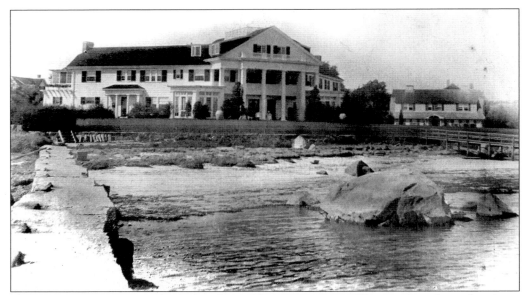

THE TAGGART HOUSE. This palatial waterfront mansion in Hyannis Port has often been mistaken for one of the Kennedy family homes. It is next door to the Kennedy compound. It was built in 1914 by Indiana senator Thomas Taggart (1856–1929), an Irish immigrant who became a leader in national Democratic politics in the early 20th century. In 1938, the home was sold to the McKelvy family. (Courtesy of Elizabeth Mumford Wilson.)

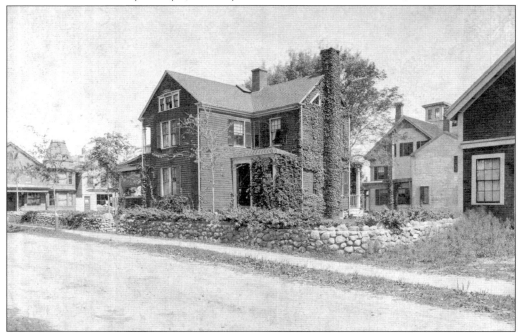

THE SOULE HOUSE. This house, owned at one time by the Soule family, stood at the corner of Ocean and Main Streets. After Martha Soule married Frank Rich, it became known as the Soule-Rich house. This photograph may have been taken around the turn of the century. (Courtesy of the Barnstable Historical Society.)

THE SOULE HOUSE. This is a front view of the Soule house. It was later torn down, and an Economy Grocery Stores was put up. That was replaced by a seafood restaurant called the Fish Shanty. (Courtesy of the Centerville Historical Society.)

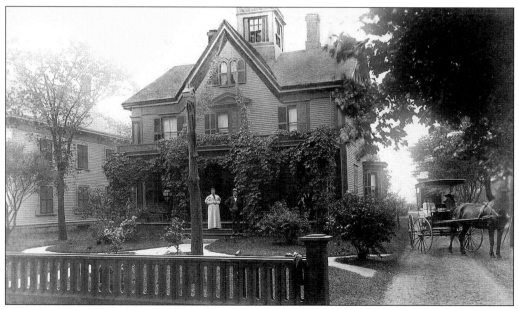

THE NYE HOME, C. 1898. This Main Street house once belonged to Mary and Charles Henry Nye, a superintendent of the railroad. Edwin G. Milk (one of Mary Nye's grandchildren from her marriage to first husband James M. Milk) was a Broadway performer before returning to Barnstable in 1950 and becoming an English teacher and pianist. This house later became in inn called the Sail Loft. (Courtesy of the Barnstable Patriot.)

THE E.L. CHASE RESIDENCE. The home of civic leader and businessman E.L. Chase was located on Main Street. (The site was later occupied by Hanlon's Shoe Store.) The home was called Gesmere, a name that may have been derived in part from the first letters of his children's first names, Gladys, Edward, and Sidney. This photograph was probably taken in 1906. (Courtesy of the Barnstable Patriot.)

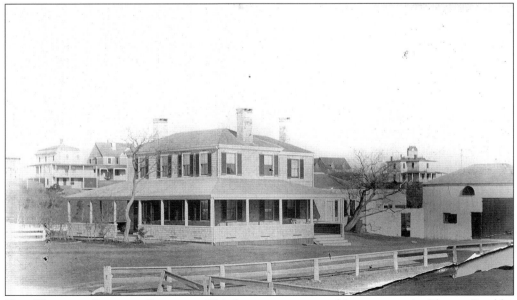

THE HOME OF ELEAZER SCUDDER. This home, once owned by sea captain Eleazer Scudder (1805–1881), was one of the first homes built in Hyannis Port. Scudder was a deepwater captain who commanded the ship *Fortuna*, among others. (Courtesy of the Newman collection.)

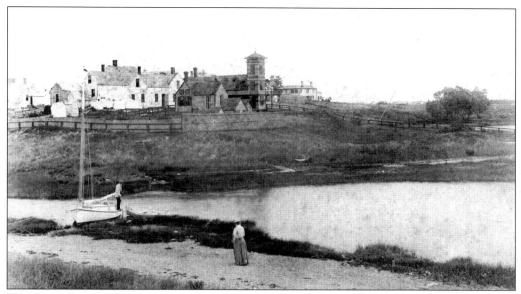

THE REED HOUSE. This home stood at the end of School Street. This photograph was probably taken before 1900. A blurb in a 1919 issue of the *Patriot* states that the "Reed cottage" on School Street had been purchased by a John A. Baxter, who planned to turn it in to a hotel. That probably became the Lewis Bay Lodge. The newspaper also reported that the "Reed house" had been purchased by a Dr. E.E. Hawes, suggesting the cottage and house were different structures. (Courtesy of the Barnstable Historical Society.)

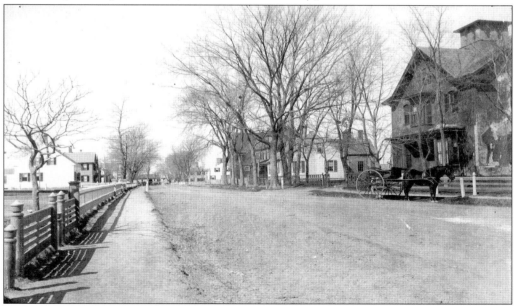

THE EAST END OF MAIN STREET. This photograph of the east end of Main Street shows Sylvester Baxter's home (far right). It was in that house in 1865 that about a dozen Hyannis women, including Baxter's widow, sowed the seeds of the Hyannis Public Library. Sylvester Baxter, who was the younger brother of Alexander Baxter Jr., was a sea captain, state senator, and deputy inspector and collector of the port of Hyannis. (Courtesy of the Hyannis Public Library.)

THE CAPT. LEMUEL B. SIMMONS HOUSE. This rambling clapboard home on Scudder Avenue in Hyannis Port was built in the early 19th century by Capt. Sylvanus Simmons, the father of Capt. Lemuel B. Simmons (1802–1892), who raised his family here. In the 1980s, it became a bed and breakfast. Perhaps the most interesting feature of the estate is the tiny resident ghost rumored to dwell in a bedroom believed to have once been hers. Her name is said to be Susan, and she reportedly drowned on the property in the 1830s. There appears to be no public record of such a tragedy, but Lemuel B. Simmons and his first wife, Temperance, had a daughter Susan, born in 1823. The younger Captain Simmons gained fame when he ordered all rum off his ships, an unpopular decree. Thus, when he sailed from Boston Harbor in the 1820s, he was at the helm of the first "no rum" ship ever to leave an American port on a foreign voyage. After retiring from the sea, he became active in local affairs and had a brief stint in the state legislature from 1868 to 1869. (Courtesy of the Simmons Homestead Inn.)

Eight

DISASTERS

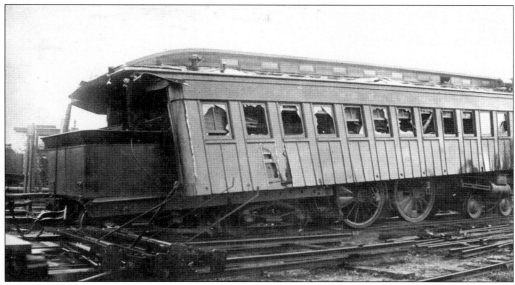

THE 1890 TRAIN WRECK. A crash of two trains on the morning of November 11, 1890, injured more than a dozen people and killed one, businessman Henry Howes of Yarmouth. The accident, which occurred near the Hyannis-Yarmouth line, was called the most serious at the time on the Cape Cod Division of the Old Colony Railroad. At around 7:30 a.m., a passenger train leaving Yarmouth collided with a work train heading in the opposite direction. The engineers of both trains had tried to stop, but by the time they saw the impending disaster, there was not enough time. The engine of the work train "plunged into the passenger train, in which there were ten people," reported the *Patriot* newspaper. The work train engine essentially telescoped the other car. "It does not seem possible a person could have escaped instant death," the newspaper continued. Among the injuries suffered by Howes was severe scalding to the face and hands. He died the next day. Howes had been proprietor of the Racket Store in Hyannis, and he took the train to the village each morning. (Courtesy of the Hyannis Public Library.)

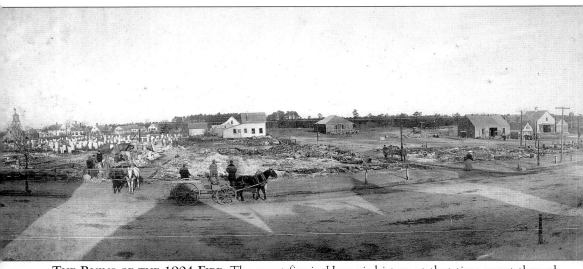

THE RUINS OF THE 1904 FIRE. The worst fire in Hyannis history at that time swept through more than a block of Main Street on December 3, 1904. All of the buildings on the north side of the street from the railroad tracks to I.W. Bacon's store were destroyed. In all, 15 structures—including the Universalist church, Megathlin's Drug Store, and many other stores—were left in ashes, nearly wiping out the business section of Hyannis. The only fatality was retired sea captain William Penn Lewis, who collapsed and died while trying to save his house. The village was alerted to the disaster in the middle of the night by grocer L.P. Wilson, who lived above his store and awoke to the smell of smoke. It was never determined whether the fire began in Wilson's market or in Walter D. Baker's department store. Although the post office burned to the ground, the postmaster was ready for business at 5:00 a.m. the next day, having set up shop in the parlor of Mrs. E.C. Benson's house on the corner of Main and Pleasant Streets. (Courtesy of the Barnstable Patriot.)

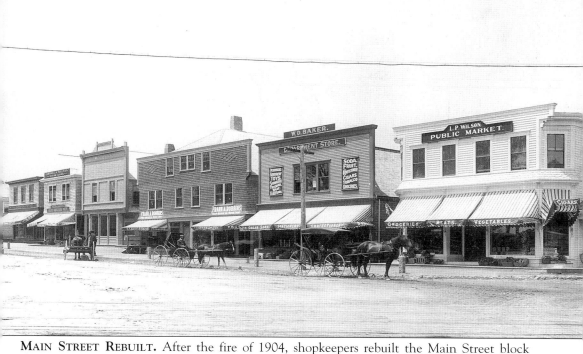

MAIN STREET REBUILT. After the fire of 1904, shopkeepers rebuilt the Main Street block destroyed by the inferno. The *Patriot* newspaper reported in January 1905, "Hyannis business men, who were burned out by the recent fire, are showing remarkable pluck and energy in getting on their feet again." W.D. Baker's Department Store, founded in 1854 as a lunch counter at the depot by Henry H. Baker, was owned by his son Walter D. Baker. Many merchants were open for business in temporary quarters, such as proprietors' homes and other shops, shortly after the fire. The Universalists were invited to worship in the Baptist and Congregational churches. Grocer L.P. Wilson and other merchants also rebuilt quickly. The new Megathlin's Drug Store was opened in April, with a large soda foundation that became a favorite destination for locals for many years. One of the twin schoolhouse at the west end of Main Street was moved onto the site of the leveled post office, given a new facade and opened as the new post office in April 1905. (Courtesy of the Barnstable Patriot.)

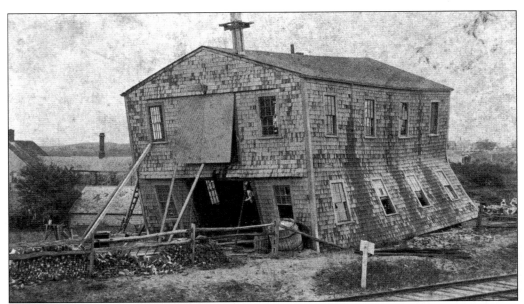

The Bond Barn Sideswiped by a Tornado. The Bond family's barn, between Ocean Street and the railroad tracks, was a service station for trains that passed it on their way to and from the railroad wharf. At the barn, run by brothers Horatio and Everett Bond, trains were maintained, replenished with coal, and repaired. It was damaged by a tornado that barreled down Ocean Street in 1900. Later, it served as a maintenance and storage facility for Nantucket Boat Inc., which Horatio Bond helped found. It burned down in 1954. (Courtesy of Ed and Sandy Bond.)

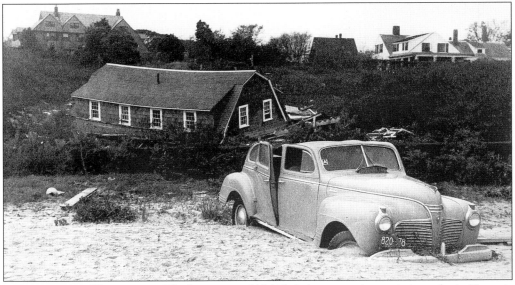

Stranded by a Hurricane. The hurricane of 1944 left this car and more in its wake in Hyannis Port. One memorable story that emerged from the disaster was the rescue by the Coast Guard of the McKelvy family from their home, the former Taggart mansion. A rope was tied around the waist of each family member, and they were pulled to safety. The only one to slip from the rope was the family dog, who then swam to dry ground. (Courtesy of the Barnstable Patriot.)

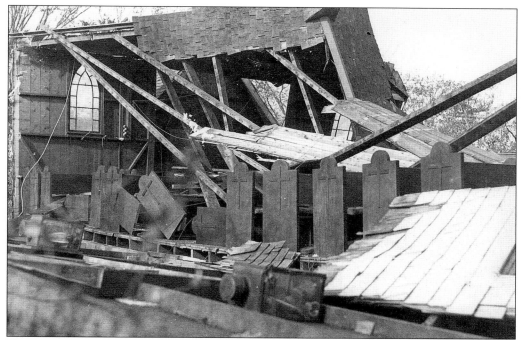

THE UNION CHAPEL AFTER THE 1944 HURRICANE. Among the buildings destroyed in the hurricane of 1944 was the quaint Union Chapel, built in 1890 in the heart of Hyannis Port. Much of the timber was salvaged after the storm, and a chapel of a much different design was rebuilt by the following summer. (Courtesy of the Barnstable Patriot.)

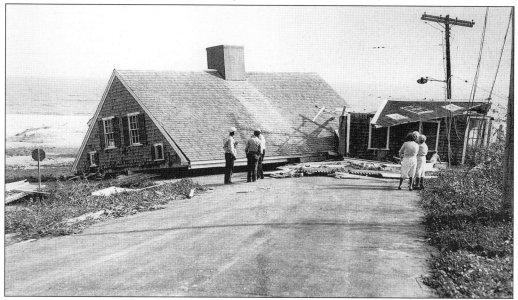

THE WEST BEACH CLUB AFTER THE 1944 HURRICANE. The West Beach Club building in Hyannis Port was demolished by the hurricane that blew through the Northeast in September 1944. A new clubhouse was built in time for the 1945 summer season. (Courtesy of the Barnstable Patriot.)

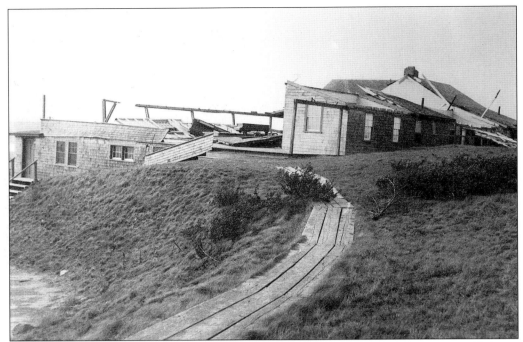

THE HYANNISPORT CLUB DEMOLISHED BY THE 1944 HURRICANE. The Hyannisport Club was destroyed by the 1944 hurricane. The roof was completely blown off. The mishap proved to be an opportunity to rebuild a more modern clubhouse, including a dining room. Hyannis Port was especially hard hit by the disaster. (Courtesy of the Newman collection.)

THE MISTRAL, HIGH AND DRY. During the hurricane of 1944, the 45-foot yawl *Mistral*, owned by the Rogean family, was thrown out of the water and plopped down on the bulkhead at Bismore Park on Ocean Street. Tides reportedly reached seven feet over the park at the height of the storm. Amazingly, the *Mistral* was not damaged. The family put it back in the water and continued sailing for the rest of the season. (Courtesy of Erma Rogean.)

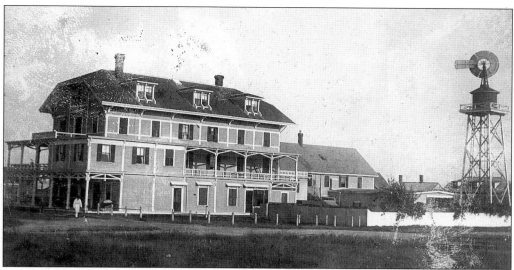

THE HALLETT HOUSE BURNS DOWN. The 1873 Hallett House was full of guests getting ready to go out for the evening when it burned to the ground on Labor Day weekend in 1905. The cause was never determined, but it was believed to have been started in a men's bathroom, perhaps by a carelessly discarded cigar or "from the lamp that lighted the room," according to the *Patriot.* No one was killed, but the loss of property and belongings was significant, particularly for those who were spending the season in Hyannis Port and had their entire summer wardrobes with them. (Courtesy of the Barnstable Patriot.)

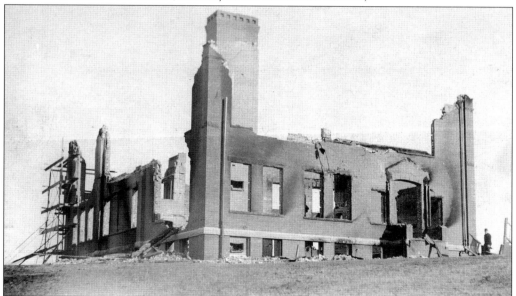

THE TRAINING SCHOOL IN ASHES. The Hyannis Training School burned down on January 24, 1896, just weeks after its completion. The fire was so ferocious and moved so quickly that townspeople who rushed to the scene shortly after 9:00 p.m. could do little but watch their new school transformed into a charred skeleton and a heap of smoldering embers. The fire was in large part the impetus for the creation of the Hyannis Fire Department, which was established later that year. (Courtesy of the Barnstable Historical Society.)

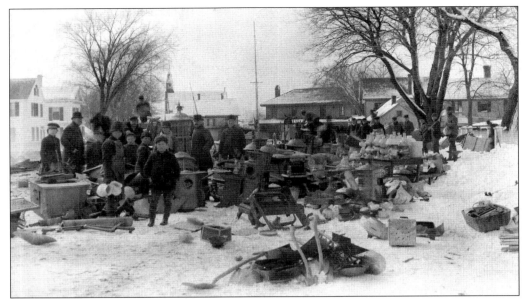

THE MARCH 4, 1892 FIRE. On the morning of March 4, 1892, the worst fire in Hyannis history at the time destroyed the Cash and Bradford hardware business (at the corner of Pleasant and Main Streets) and the adjacent Boston Store, which was a dry goods shop run by P.M. Crowell. Also wiped out were Augustus B. Nye's paint shop and Joyce Taylor's grocery store, both housed in the Cash and Bradford building. (Courtesy of the Barnstable Historical Society.)

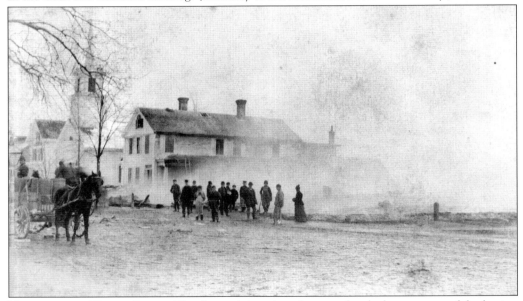

NEIGHBORING HOMES SAVED. The fire took just three hours to level what was one of the busiest corners in town. Snow on the ground and action by townspeople prevented the fire from spreading to other buildings, including to hardware proprietor Alexander G. Cash's home next door. Rugs were nailed to the roof of Cash's house and other buildings and were drenched with water from his kitchen pump. Cash's home was saved, but the sides were charred and his furniture had been taken out and piled in the snow. (Courtesy of the Barnstable Historical Society.)

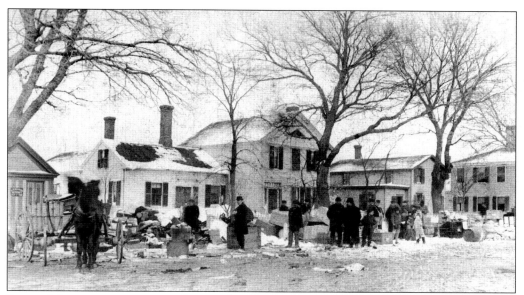

SAVED MERCHANDISE IN THE SNOW. As there was not yet a fire department in Hyannis, townspeople could only fight the inferno by filling water buckets at the town pump. The *Patriot* newspaper reported, "With these primitive weapons no headway whatever could be made, and the flames soon made way through the roof and windows, and a strong north wind soon put all idea of checking it out of the minds of the crowd that had rapidly gathered." Hundreds of townspeople helped removed goods from the stores. (Courtesy of the Barnstable Historical Society.)

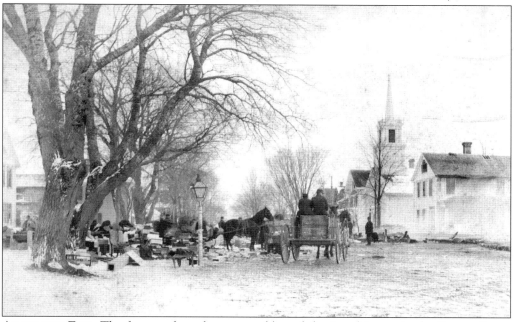

AFTER THE FIRE. The fire may have been caused by a defective chimney in the Boston Store, where the blaze started. The financial loss to the businesses was eventually estimated at $45,000. After the fire, Alexander G. Cash built the Cash Block, a business center, on the site. (Courtesy of the Barnstable Historical Society.)

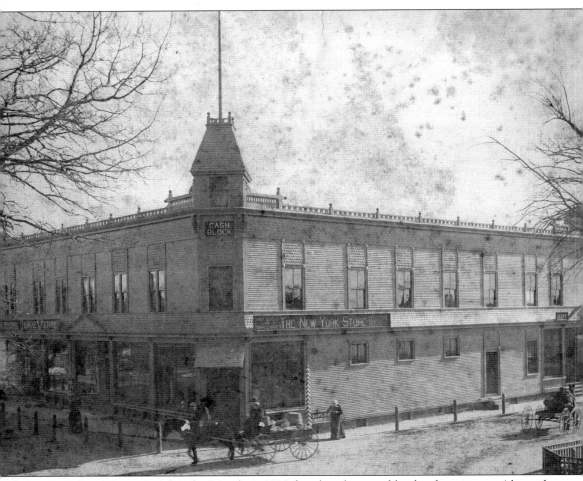

THE CASH BLOCK. After the March 4, 1892 fire that destroyed his hardware store, Alexander G. Cash, who was a Barnstable selectman, built a larger building on the property the following year at a cost of about $15,000 and called it the Cash Block. Cash, however, left the hardware trade after the fire, and Myron G. Bradford became sole proprietor of the business, which was then renamed Bradford's Hardware. The handsome building also housed a number of other businesses, including the New York Store, which was a furniture, dry goods, and clothing store owned by the Eagleston brothers. In the cellar was a bowling alley, a barbershop, and a pool hall. The Cash Block was completed in the fall of 1893, and the Eagleston brothers celebrated the opening of their store in October with tours of the building, music from the 20-piece Hyannis Cornet Band, and musical talents imported from neighboring towns. "It is expected to be a gala day in Hyannis," reported the *Patriot* of the upcoming opening celebration. Today descendants of Harry Bearse, who bought the business in 1933, are still selling hardware from the same store at the corner of Main and Pleasant Streets. Down in the basement, the paint is fading on the unused bowling lanes. They may be covered with boxes of inventory, but the remnant of another time is still there. (Courtesy of the Barnstable Historical Society.)